NORTH ALABAMA
BEER

NORTH ALABAMA
BEER

An Intoxicating History

Cheers!
S. Bélanger

Enjoy!
Kamara Bowling Davis

SARAH BÉLANGER & KAMARA BOWLING DAVIS

Foreword by Danner Kline, Founder, Free the Hops

AMERICAN PALATE

Published by American Palate
A Division of The History Press
Charleston, SC
www.historypress.net

Cover photo by Sarah Bélanger.

First published 2017

Manufactured in the United States

ISBN 9781467136648

Library of Congress Control Number: 2017938349

This book is dedicated to my husband, Olivier Demaneuf, who deserves an entire chapter of thanks for all the assistance he gave to writing this book but who will have to settle for a sentence; to my mother, Robin Simpson Bélanger, who somehow always had faith that her messy, dyslexic daughter would become a published author; and to my father, Mark Bélanger, who gave me my first sip of beer and inspiration for this book.
—SB

Oh, the irony! My parents, Ted and Carolyn Bowling, devoted their lives to make sure that I was shielded from the evils of alcohol, and yet my first published book is a history of beer. This book is for them because they trusted that I would respect their teachings while I explored and became the adult I am today. My decisions were not always supported, but I was always loved. For that and so much more…thank you.

And for Sean, my steady support. Your belief in me inspires me to keep trying.
—KBD

CONTENTS

FOREWORD

At the beginning of 2017, there were thirty-four members of the Alabama Brewers Guild. That includes both operational breweries and breweries in planning, but most of the eight still in the planning stages will come online over the next few years.

Ten years ago, anyone familiar with beer culture in this state would have laughed in your face if you had suggested there would be more than thirty breweries here a decade later. After all, in 2007, there were three brewpubs and one production brewery in operation in Alabama, all of which have since closed. At that time, our state laws put more restrictions on the production and sale of beer than any other state in the union.

In early 2007, Free the Hops—the group I founded to reform those onerous legal restrictions—was gearing up for its first attempt at passing a bill in the state legislature with the aid of a full-time lobbyist. We would fail spectacularly that year, ultimately being awarded the Shroud Award, a humorous award given to the sponsor of the "deadest" bill of the session.

Hundreds of other bills that failed to pass that year were just as dead, but our bill was deemed the deadest because of the drama surrounding it. State legislators warned that it would increase drunkenness and tear families apart. A representative by the name of Alvin Holmes became an Internet sensation with a viral audio recording of a moment during legislative debate of the bill in which he asked, "What's wrong with the beer we got? I mean, the beer we got drink pretty good, don't it?"

New types of craft beer were unnecessary and almost certainly dangerous—at least, that was the prevailing sentiment. But we refused to quit, kept working to educate the legislators and finally got our first bill signed into law in May 2009. That bill raised the limit on alcohol allowed in beer from 6.0 percent by volume to 13.9 percent, effectively legalizing dozens of styles of beer previously unavailable in the state. It made the prospect of opening a small brewery much more attractive.

Pass it, and they will come. Once that change became law, dozens of home brewers in Alabama began to seriously look at going pro. It started slowly with just a handful opening in the first few years after the market opened up. But the movement gained steam, and more have opened each year since.

Those legislators in 2007 had no idea how much of a boon the brewing industry would eventually be for the state. In addition to the jobs created by direct employment at breweries, other businesses launched around the beer industry and around the locations of the breweries themselves.

The food truck explosion coincided with the rise of local breweries, as the two business models developed a symbiotic relationship. Breweries operate taprooms that sell beer but no food, while food trucks serve food but no alcohol. The food trucks park outside the breweries, each of which offers complementary products.

Bottle shops opened specifically to sell the huge variety of new beers.

A keg leasing company opened in Birmingham to provide kegs to the breweries—a demand that hadn't previously existed.

Entire entertainment districts sprung up after breweries opened in distressed areas. There are now more than a dozen businesses operating in the Avondale district in Birmingham that never would have existed if Avondale Brewing Company hadn't opened to anchor an area that previously had nothing to attract consumers.

All of this economic development did not go unnoticed by the state legislature. It went from calling the FTH bill the deadest of the 2007 session to overwhelmingly voting to pass a bill allowing to-go sales at breweries nine years later. Positive change begat positive change. And no one suspected that positive economic change would start by legalizing fancy beers.

In the nearly thirteen years since Free the Hops began, Alabama has transformed from a barren wasteland of craft beer into a model of legislative and cultural progress with that beverage. Our state is not known as one that loves change, but get a few IPAs in us and see what happens.

—DANNER KLINE

ACKNOWLEDGEMENTS

We would like to raise our pints and offer a toast or two to the many amazing people who helped us bring this book to fruition.

We would first like to toast all those hardworking volunteers at Free the Hops, the Alabama Brewers Guild and the Right to Brew who fought diligently for the right to drink good beer and, in doing so, created a captivating story for us to explore.

A toast also to the brewers and anyone in the craft beer industry, not just for creating awesome beer but for sitting down to lengthy interviews and then answering our numerous follow-up questions, often late at night.

A toast to Danner Kline for founding Free the Hops and being the spark that ignited the fire that became a craft beer explosion. Thank you also for your wonderfully insightful foreword and for participating in numerous interviews. A toast to Dan Roberts for his incredible work with Free the Hops and Alabama Brewers Guild and for inspiring the young invincible warriors fighting for craft beer freedom. And a special shout-out to Free the Hops president Carie Partain for helping us speak to all the right people.

A toast to our History Press commissioning editor, Amanda Irle, and senior editor, Ryan Finn, for answering *so* many questions and giving us the tools to write our first book.

A toast to our predecessor Carla Jean Whitley, who wrote the wonderful book *Birmingham Beer* (our copies are now dog-eared from reading it so many times) and helped us through this interesting process.

A toast to the numerous historians, archivists, librarians and historical societies that pulled many sources, shared their expertise and enthusiastically

answered our endless stream of questions. Your love of history is inspiring, and your support to this venture was indispensable. Special thanks go out to John Allen, John Allison, Danny Crownover, Kathrin Webber Carroll, Cammie Flowers, Lee Freeman, Drew Green, Peter J. Gossett, William Hampton, Cindy Hewitt, Dr. Kaylene Hughes, Thomas Hutchens, David Ireland, Mandee Jones, Pat Mahan, Dorcas Raunich, Henry Turner, Judy Weaver, Richard White and Dr. Julie Williams.

A toast to Linda and Homer Hickam for hosting the Monte Sano Writer's Conference, which provided us with the springboard and inspiration for this project.

TOASTS FROM SARAH

A toast to Olivier Demaneuf, who read, edited and reread this book numerous times. Thank you for your massive support and for joining me on this book-writing journey, which you did not expect to take.

A toast to the many friends and family who cheered us on. A special thank-you to Robin Simpson Bélanger and Evan Bélanger for their unwavering support. Thank you to Deidre Hopkin and Rebecca Walker Benjamin, who endured months of beer talk and then did not take it personally when I ignored them for the month before the deadline.

TOASTS FROM KAMI

A toast to Sean Davis, for his incredible patience, tolerance and support of each of my crazy ambitions. Thank you for all your help with this project and for believing in me, especially when I did not believe in myself.

A (non-alcoholic) toast to Lori Purves Moore, for giving me my first book on writing and telling me that I could.

A toast to Heather Webb Nipper, April Jackson Siotis, Robin Cox Weeks and Tanya Ritchie Colburn, the girls who encourage and challenge me to be the best that I can be. I hope I make you proud.

A toast to Susan Burlingame, Richard Adair, Pat Brooks, Katelen Creasy, Suzie McGehee, Stephanie Potts and Monica Yother for their enduring patience, inspiration and help throughout this project.

And lastly, a special toast to the late Dr. Larry Nelson, who taught me that "good history is intellectual history."

Cheers!

INTRODUCTION

When Free the Hops first started advocating changing beer laws in 2004, many people said it was never going to happen—not in Alabama. Critics to changing brewing laws warned that stronger beer would bring back violent saloons and that the highways would be riddled with drunk drivers. Neither of these things happened.

The state's temperance-minded residents prided themselves on having some of the strictest liquor laws in the country, and many legislators seemed uninterested in changing that. The first time Free the Hops' beer bill went to the state legislators in 2007, it failed. But Free the Hops stayed the course and continued to reeducate legislators and the public. Its diligence paid off, and the bill passed two years later in 2009.

Even in 2017, there remains a certain amount of disbelief that Alabama changed its restrictive beer laws. While doing research for this book, one phrase I heard over and over was, "If you told me ten years ago that Alabama would have a craft beer industry, I would have never believed you." This was, after all, the state that hosted the world's largest *dry* Oktoberfest for decades in Cullman. But the laws did change, and once that happened, the craft beer industry would not be stopped.

In the spring of 2009, I went to Mason's Pub in downtown Huntsville with my good friend Alexander. Unbeknownst to me, Governor Bob Riley had just passed the Gourmet Beer Bill, allowing Alabama to sell and manufacture beer with more than 6 percent alcohol in it. Our trip to Mason's was the first day that the higher-alcohol, or high-gravity, beer

could be served in Alabama since 1915, so the pub was packed with celebrating beer aficionados. Although I had heard of Free the Hops, I, like many other Alabamians, was only vaguely aware of what it was trying to accomplish by pushing the Gourmet Beer Bill. But as I sat in the crowded pub drinking my first malty stout, I instantly appreciated its efforts. From then on, I took more notice of Alabama's legislative changes in the beer industry.

It was my friend Torie who really introduced me to Alabama's craft beer industry in 2011, by taking me to Birmingham's numerous breweries and craft beer bars. We sipped flights, discussed flavor profiles and were always on the hunt for something new.

I watched as North Alabama went from having one brewery to five breweries to fifteen breweries, with more on the way. In 2013, I was working as a freelance food writer and photographer, but as the local beer market grew, I found myself writing more stories about the craft beer industry. Although I greatly enjoyed drinking the beer, it was the people and their struggle to legalize their craft that really captivated me. Many of the home brewers I talked to were upstanding citizens, without so much as a traffic violation, who spent decades breaking the law by brewing beer. And not because they had nefarious plans to sell their beer on the black market; rather, they simply loved the process and the product. For me, they are the heart of the modern-day beer story.

I met my writing partner, Kamara "Kami" Bowling Davis, in 2014 at the Monte Sano Writer's Conference. Both of us were late to the conference, parked in the wrong parking lot and walked into the wrong building together; neither one of us expected that such a scattered-brained moment would eventually lead to us writing a history book together three years later.

Two weeks after we signed the contract for this book, I discovered I had a wheat allergy and could no longer drink beer. Although it was disappointing—seriously disappointing—that I could not drink the product I was writing about, it allowed me to see breweries as more than just places that make beer. Most of North Alabama's brewery owners, if not all of them, are valuable part of their communities, support numerous charities, empower their employees and create a continuous stream of revenue for the state of Alabama. The modern-day breweries are a far cry from the wild saloons of the early 1900s that spurred violence and debauchery and were a menace to Alabama neighborhoods.

This book examines Alabama's complicated relationship with beer over the years—from the early saloon days to Prohibition and the recent

revitalization of the local beer scene. It also covers the individual origin stories of each current brewery in the Tennessee River area. For the most part, the book is organized in chronological order, except for the brewery section, which groups each brewery by region.

There are several things to take into consideration when reading this book. First, the term "alcoholic beverage" refers to both hard-distilled liquors and fermented malt beverages. During our research, Kami and I found that the two products are intertwined and difficult to separate. Many of the early laws made reference to liquor or alcohol, so we assumed that malt beverages were included in these laws; however, it was just that—an assumption. Additionally, our research covering the earliest years of Alabama yielded very little information about beer or malt beverages specifically. Because of this, we included the history of hard liquor legislation in this book to give the reader an overview of the region's relationship with all types of alcohol during this period.

Second, history is a subject that can strangely change over time. Information is discovered that can negate previous assumptions. For example, we found many publications that said that Alabama's first brewery started in 1878, but previously undiscovered documentation showed that Huntsville had a brewery as early as 1819. We have therefore written that Alabama's first brewery began in 1819, but that may change if an earlier brewery is discovered. Although Kami and I did our best to use primary sources, as well as search extensively for the most accurate information, new information may be found in the future that could contradict some of our statements. Please do not hold that against us.

Third, we strove to create an unbiased look at the history of beer in North Alabama. We included the violent, wild saloon days but also the charitable efforts of many modern-day breweries. The truth is that Alabama has had a complicated history with alcohol since the end of the nineteenth century, and therefore people will have a wide variety of opinions about it, including us.

Lastly, this book is woefully incomplete. There are so many stories and people that deserve to be in this book but got left out simply because we did not have the time or space to include them. Although Kami and I spent thirteen months doing research for this book; read hundreds of newspaper articles, numerous books and countless blog posts; and drove well over two thousand miles to visit each brewery, as well as archives and libraries, it simply was not enough. There are so many more tales to be uncovered and explored, so I encourage all those interested in beer and history to

continue researching this subject. That might mean sitting in a library flipping through two-hundred-year-old newspapers or sitting in a brewery drinking a pint; both will give you a richer understanding of what turned out to be a surprisingly complex subject.

TIMELINE

1819—Alabama's first commercial brewery, the Huntsville Brewery, opens.

1828—Alabama's first temperance society is formed in Tuscaloosa.

1873—Formation of the Woman's Christian Temperance Union in Ohio.

1898—The Government Dispensary System starts in Alabama.

1902—Carrie Nation visits Huntsville, Alabama.

1907—Local option laws begin shaping Alabama.

1909—Carmichael State Prohibition Law, known as the "bone-dry law," goes into effect and ends the sale of all alcoholic beverages in Alabama.

1911—Alabama's first prohibition is repealed, reverting back to the dispensary system.

1915—Statewide prohibition is reinstated.

1920—The Eighteenth Amendment takes effect, establishing the prohibition of alcoholic beverages in the United States.

1933—The Twenty-First Amendment repeals national prohibition.

1937—End of Alabama's statewide prohibition.

1992—The Alabama Brewpub Act opens the door for brewing establishments located in historic buildings.

2004—Olde Towne Brewing Company, first microbrewery in Huntsville since the repeal of prohibition, opens; Danner Kline founds Free the Hops.

2009—First annual Rocket City Brewfest.

2009—Gourmet Beer Bill is passed, raising ABV from 6.0 percent to 13.9 percent.

2011—Brewery Modernization Act is passed, allowing breweries to operate a taproom and removing many of the restrictions placed by the 1992 Brewpub Act.

2011—Cullman's dry Oktoberfest goes wet.

2012—Gourmet Bottle Bill is passed, increasing the container size from 16.0 ounces to as much as 25.4 ounces.

2013—Homebrewing Bill legalizes home brewing, allowing citizens not living in dry counties to brew up to fifteen gallons of beer, mead, cider or wine in a three-month period for noncommercial consumption.

2015—First Annual Albertville Brewfest.

2016—Beer to Go Bill is passed, allowing breweries producing fewer than sixty thousand barrels per year to sell up to 288 ounces of beer, per customer per day, directly from the brewery for off-premises consumption. It also allows the donation of up to two kegs to licensed charity events and removes the restriction on locations for brewpubs.

EARLY ALABAMA BEER

B eer is one of the oldest manufactured beverages. Six thousand years ago, ancient Egyptians drank thick, lightly fermented beer with straws out of communal bowls. Almost four thousand years ago, the Sumerians celebrated Ninkasi, the goddess of beer. During the Middle Ages, European monks brewed robust ales in their monasteries. Throughout history, beer has been used to celebrate life, dull pain and nourish the body. In North Alabama, beer has been around for centuries, and although it faced periods of dormancy, it always came back resiliently.

Certain Native American tribes drank an alcoholic beverage made with fermented agave sap called "pulque," but it is likely that our modern version of beer came to the United States with the European immigrants. When the *Mayflower* brought Pilgrims to the Americas in 1620, the boat was filled with barrels of beer to sustain its passengers on the two-month journey. In those days, beer was a lifesaving commodity for long sea voyages. It had essential nutrients and calories and did not become brackish like stored water. Although the *Mayflower* planned to land in Virginia, the beer supply got dangerously low, so Captain Christopher Jones decided to dock at Plymouth Rock, Massachusetts, to preserve the rest of the beer for the journey back.

Beer would continue to be an important commodity in the American colonies, but unlike harder spirits, which were imported from Europe, beer was produced domestically with native wheat and barley. Prior to the 1800s, beer in North Alabama was likely produced in the home for family

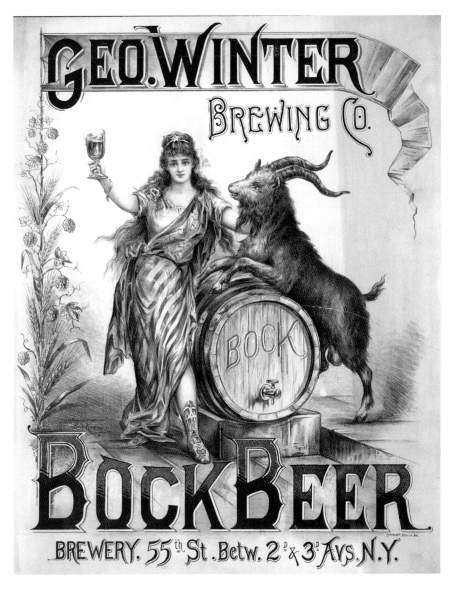

An advertisement for bock beer from the Geo. Winter Brewing Company from 1900. *Library of Congress.*

consumption, and so most of the early records and legislation concerning alcohol in Alabama focused on harder spirits rather than malt beverages and beer.

As Spanish, French and British immigrants continued to enter the Alabama terrain throughout the 1600s, they brought with them rum,

wine and brandy from their native lands. English immigrants were skilled at brewing English ales and stouts, whereas German immigrants brought bocks and German-styled pilsner recipes with them to the New World. Making beer and whiskey was a good way for farmers to salvage successful harvests and save excess grain from rotting in silos over the winter. Although the immigrants were skilled at brewing a wide variety of malt liquors, it is likely they would have had to tweak their European recipes to make them suited for the accessible American grains. Additionally, hops in Alabama may have been different than the European variety. Despite hop crops needing freezing winters to thrive, there is evidence of hop yards growing in Huntsville in the 1800s. Even today, farmers are experimenting with different hop varieties to see which type will grow in Alabama's mild winters.

Imported liquor in the newly acquired territories was considered an essential part of civilized society. It was also deemed a healthy and safe alternative to water, which would often contain harmful bacteria or disease. On May 18, 1733, Jean Baptiste Le Moyne Bienville from the province of Louisiana illustrated this sentiment when he wrote to his friend complaining that the price of wine was so high that three-quarters of the officers were forced to drink water, and as everyone knew, water "impairs the healthy [person] considerably in hot climates." Alcoholic beverages were so much a part of standard living that the military issued hard spirits to the troops as part of their rations. According to the book *Prohibition Movement in Alabama, 1702–1943*, in 1724, the French military issued fifty pots (equivalent to fifty quarts) of brandy to each soldier each year. But a reliance on fermented drinks meant that some people drank too much, which led to poor health, idleness and even violence.

Excessive selling and drinking of alcoholic beverages were feared to become an issue, so laws in the southeast territories were quickly passed to curb the threat. As early as 1726, the French Superior Council enacted a law that required all dram shops to remain closed during Sunday church services. In 1733, the same council passed an ordinance stating that only licensed dealers could sell wine, brandy or any other liquor by the pint. The council was also concerned with the risk of retailers overcharging customers, so it set numerous rules regulating prices. But it was the British who started taxing alcoholic beverages in 1766 in the southeast territories and again in 1768 and 1770. The generated revenue was used to build and maintain roads.

In addition to regulating who could sell alcoholic beverages and how to tax it, laws were created to regulate who could buy it. The public especially

feared slaves and Native Americans having access to liquor, thinking they were more likely than their white counterparts to become irrational and violent while intoxicated. Throughout the 1700s, laws were created that reflected these fears. As early as 1727, the French made it illegal to sell liquor to slaves or even trust them with it without written orders from their masters. In 1765, the Council of West Florida created a law to limit and control liquor consumption in the Native American tribes. The law stated that only "His Majesty's Superintendent of Indian Affairs" or his deputies could sell, exchange or give spirituous liquor to the Native Americans, and only during a one-month period of the year. A year later, the same assembly created a law making it illegal for anyone to "give, sell, utter, or deliver to any Slave or Slaves any Beer, Ale, Cyder, Wine, Rum, Brandy, or other spirituous liquors whatsoever without the leave or consent of the Owner or Other Person having charge of such slave or slaves."

Similarly, as poor European immigrants moved to America, fear grew that they could not handle the temptation of alcoholic beverages either. In 1766, a law was created that forbade the sale of liquor to common laborers; sailors were restricted in how much they could purchase. As for women, they were not legally restricted from drinking, but social pressures and lack of rights meant that it was nearly impossible for them to drink if their husbands or families did not approve.

Fear and archaic views meant that most of the restricting laws during this era simply banned liquor from everyone but the wealthier white males of the community.

THE 1800s PRE-PROHIBITION ALABAMA

North Alabama Saloons

It was not long after coming to the New World that the European immigrants built taverns and saloons. The oldest bar in America, the White Horse Tavern in Rhode Island, started serving alcohol in 1673, more than one hundred years before the Revolutionary War and the birth of the United States of America.

In the 1700s and 1800s, taverns and saloons were a well-established part of Alabama culture, and they peppered the state's frontier well before it earned its statehood. An ample supply of corn made whiskey a staple in Alabama, but saloons also served ale, wine, hard liquors, cigars and even meals. It was common practice to serve salty dishes such as salt pork and nuts, which encouraged imbibing alcohol.

Three such popular drinking holes in the 1800s were Dunn's Tavern in Huntsville, the Motlow Saloon in Gadsden and the Palace Saloon in Cullman. They were, as with most saloons back then, places for white men to relax, socialize, conduct business and discuss politics (with a frothy pint or shot of whiskey in hand, of course). Saloons and taverns were vital to the political and business operations of a town but were yet another part of society where women and minorities were not allowed.

Some taverns were literally centers for legal proceedings. Such was the case with Huntsville's Bunch's Tavern in 1810, which was also the home

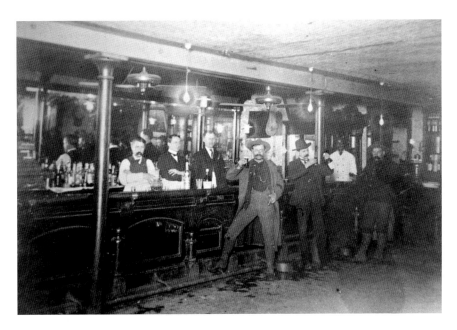

Patrons drinking in a Huntsville saloon in the 1800s. *Henry Turner.*

of the newly formed Madison County court system. Bunch's Tavern was built with a double-walled structure to resist Native American attacks (which never happened); it was also large enough to accommodate a crowd, which made it a good location for the January session of Superior Court in 1810. The sheriff renovated the tavern to accommodate the judicial proceeding. The renovation included the addition of three homemade chairs, one table, stacks of paper and goose quills. When court was not in session, Bunch's went back to being a tavern, serving liquor and meals to its patrons.

Drinking and politics seemed to go hand in hand. When U.S. President James Monroe paid a surprise visit to Huntsville in 1819, much liquor was imbibed to celebrate the occasion. During the festivities, President Monroe and one hundred attendees of delegates and prominent Huntsvillians toasted Alabama's future prosperity and its road to statehood. Monroe himself issued a toast to statehood, saying, "The territory of Alabama, May her speedy admission into the Union advance her happiness, and augment the national strength and prosperity." One month later, Huntsville's saloons would be full of politicians from across the territory who were there to make Alabama a state. In July 1819, men from all across the territory, including eight Madison County delegates, packed into a sweltering building in downtown Huntsville

to write the state's constitution. For weeks, county delegates argued about what kind of state they wanted to become, all while enduring the hot and humid Alabama summer. The windows of the tiny building stayed closed to keep the prying eyes and ears of nosy Huntsvillians out, so the delegates didn't even have a gust of wind for heat relief. During their breaks, the politicians would pour into the local saloons and enjoy drafts of porter or nips of whiskey before heading back to the sweltering building to do their civic duty. Two of the delegates enjoyed the saloon life perhaps too much, and it was reported that they showed up noticeably intoxicated to the final signing of the constitution. Despite this, they signed a document that, five months later, would transform the territory of Alabama into the twenty-second state of the Union on December 14, 1819.

Dance Halls

Another popular drinking location was the dance hall. They speckled the state and were filled with young men and women looking for a fun time. Huntsville even had a popular underground dance hall nestled within a cave. In the late 1800s, Major Fuller bought the cave and installed a generator so he could put electric lights inside it, which was impressive at a time when few Huntsvillians

The entrance of Shelta Cave, which housed a dance hall in Huntsville in the late 1800s. *Henry Turner.*

had electricity. He added a wooden building at the entrance, placed stairs, built a dance floor and named the cave Shelta, after his daughter. Fiddlers and other musicians provided the music for Shelta Cave. Dance halls were one of the few places where it was acceptable for women to consume alcohol, since a good upstanding woman would never have been found or even accepted in North Alabama's numerous saloons.

Alabama's First Brewery: Huntsville Brewery

On September 11, 1819, brothers James and William Badlun placed an advertisement in the *Alabama Republic* about the upcoming opening of their brewery, aptly named the Huntsville Brewery. The ad was placed three months before Alabama gained statehood, making it the first known commercial brewery in the state. The ad read, "The subscribers respectably inform the public that they will commence Brewing in a few days, and will have ready for sale in three weeks. Porter, Ale, and Beer, of quality inferior to none, by the barrel or smaller quantity." The brothers were offering the highest price of cash for barley, rye and wheat, likely for the production of their brew. The Huntsville Brewery was the only brewery in operation in the state of Alabama at that time. It stood at the edge of Huntsville and included fourteen acres of property, including two acres of hop fields; a large dwelling with a separated brick kitchen; a malt house; a gristmill for grinding corn; and all the brewing equipment needed to produce porter and beer. The Badlun brothers also owned a bakery and grocery store in downtown Huntsville. Many of the grocery stores in Alabama were selling imported porters and ales from up north, so commercially brewing local beer and selling it in their own grocery store must have made sense for the brothers.

Numerous newspaper ads stated that brewing was about to begin at the Huntsville Brewery, but there is little evidence as to when they started distributing their product. The brewery's inventory list did include bottles of porter, which were most likely sold in one of the local saloons or in the Badluns' own grocery store. One thing is for sure: the brewery did not remain open very long, as the brothers suffered a series of misfortunes just as the brewery was about to open.

The first setback was the loss of one of the brewery's workers, German-born John Newbold. Seventeen-year-old Newbold came to the United States as a redemptioner. Redemptioners were poor European immigrants who did not have the means to pay for their travel expenses to the United States but

agreed to a period of indentured servitude to a business or individual in exchange for paying their way. This was a common practice in the 1700 and 1800s, and more than half of the German immigrants from this period came to the United States this way. Newbold had done just that, traveling from Germany to America, but after a period of service in Philadelphia, he was leased to the Badlun brothers in Alabama. Servitude was a steep price for passage to the States. Often, the immigrants were obliged to work for four to seven years to pay off their debt, and during that time, they had limited freedom and

An advertisement for the Huntsville Brewery created by the Badlun brothers. It was Alabama's first commercial brewery. Alabama Republic, *September 11, 1819.*

were not allowed to marry. They were considered their master's property and could be traded or leased to another individual at any time with little choice in the matter. Perhaps it wasn't the type of work that he envisioned for himself (brewing can be backbreaking), or maybe the hot Alabama summers were too much for him, but after five months of servitude, Newbold ran away and left the brothers high and dry. The Badluns were eager to get him back and placed a twenty-five-dollar reward for his return. They described him as large for his age, thick set, freckled and having a "rather sulky look." The September 18 advertisement in the *Alabama Republic* stated that he was dressed in a pair of checked pantaloons and a light gingham coat. But despite the brothers' efforts to find their runaway, it is doubtful they ever saw Newbold again.

Just one week after Newbold's disappearance, the Badluns faced another setback. The brothers employed Englishman Thomas Evans in their grocery store. On the night of September 22, Evans stole $315 in cash, four new bridles, three snaffle bits and a curb. The day before, he had bought a fine brown horse on credit from the brothers, so they knew they were swindled out of that money as well. The want ad described Evans as "5 feet 6 inches high, an Englishman by birth, stout, thick set fellow, red face, large grey eyes, very thick nose, which is turned one side—rather of a bashful down look." The thief had been a painter by trade and left Huntsville with three companions. The Badluns were even more anxious to catch Evans than they

were Newbold and offered $100 as well as traveling expenses to bring him back to Huntsville. It was suspected that Evans had escaped to Georgia, so the brothers took out reward advertisements in eight newspapers, including Huntsville's *Alabama Republic*, the *Georgia Advertiser*, the *New Orleans Gazette* and the *Savannah Republican*. It is doubtful they got their justice, and it was most likely a financial setback to the brothers and their businesses.

Throughout 1819, James Badlun had been borrowing money from several individuals, but after September, he borrowed a large sum of money, $635.32, from William McNeill. One can assume it was to cover the financial losses of his rogue employees. William Badlun was the guarantor of the loan, but the debt was too much for the brothers to pay back. And so, a year later, in September 1820, an ad in the *Alabama Republic* stated that the brothers' creditor, William McNeill, was now managing the brewery formerly managed by the Badluns. It further stated that McNeill was purchasing barley in order to start brewing, and by January 1821, an ad was placed reading, "The subscribers have constantly on hand, of an excellent quality, PORTER AND BEER, for sale by the barrel."

By February 1821, the Badluns' debt payment was long overdue, so Madison County foreclosed on half of the Huntsville Brewery, which was auctioned off by Sheriff Stephan Neal. It was William McNeill, the creditor of the loan itself, who bought the foreclosed property at the auction, thus making him an official owner of half the brewery.

The Badluns would continue to struggle with tragedies. William's wife, Elizabeth, died in 1822 at only forty-three years old. The brothers eventually sold their remaining half of the brewery in February 1823 to Thomas Banister for $1,280. After Banister, the brewery changed hands several times, but eventually William McNeill would own it in its entirety.

In 1827, William McNeill put the Huntsville Brewery up for sale again, and not much is known about it after that.

Over the years, other breweries would come to Alabama. By 1840, the state had seven commercial breweries. In Madison County, the Christian Fromm Brewery opened in 1874 and lasted just one year. The William Strube Brewery fared a little better and was open from 1870 until 1874. But it is the Badlun brothers who hold the distinction of owning the first commercial brewery in Alabama. In 2016, the Alabama Brewers Guild released a collaboration beer as a tribute to the Badlun brothers and the state's first commercial brewery: the Badlun Brothers' Imperial Porter, which is a rich, dark English-styled porter brewed with traditional ingredients but for the modern palate.

CULLMAN'S GERMAN IMMIGRANTS

Beer was drunk all across Alabama in the 1800s, but some areas had strong cultural ties to beer. One such place was Cullman, thanks to its enduring German heritage. Many German immigrants knew how to brew beer and brought that knowledge with them to the state. German beer is historically brewed under very strict standards and adheres to a German Beer Purity Law, or *Reinheitsgebot*, that dictates a limited set of ingredients that can be combined into a brew in order to be considered beer. Beer was an important part of German culture and identity; therefore, immigrants valued good German-style beer and brewed it in their new homeland. This was the case in Cullman, which was started by five German families in 1873.

A German colonel named Johann Gottfried Cullmann founded the city of Cullman. In the mid-1800s, Colonel Cullmann got into political and financial trouble in his home country of Germany after participating in the Revolution of 1848. Because of this, he moved to the United States in the 1860s and eventually discovered a relatively unsettled area in Alabama where he could build a town. He convinced several German families already living in the States to help him establish a new town, which would be named Cullman. Cullmann loved the new territory because it reminded him of his Bavarian homeland. His vision was to create a new German community with fellow expats based on old-world culture and customs. The town had a prevalence of German food, beer and, as early as 1876, a lager brewery, four saloons and a beer garden.

One of Cullman's earliest residents was German-native, entrepreneur and beer brewer Amalia Dinckelberg. Dinckelberg was living in Cincinnati with her husband when they became acquainted with Colonel Cullmann. They decided to follow him to Alabama, where they spent the rest of their days. Dinckelberg owned several businesses, including a beer garden. The garden stayed open until prohibition came to Alabama in 1915.

Saloons were also quite popular in Cullman. Children were sent to them with empty buckets, called growlers, to collect beer for their households. Sticking to European tradition, the German residents would take an afternoon break and visit the saloon for beer and socializing. The Richter Hotel was one such place, an early favorite to grab a pint. The owner, Wilhelm Friedrich Richter, was born in Militsch, Germany, in 1837. Around 1876, Richter moved to the developing German community of Cullman with his young wife, Julianna, and their children. Shortly after arriving, he started the Richter Hotel, which included an attached saloon. Richter brewed his own

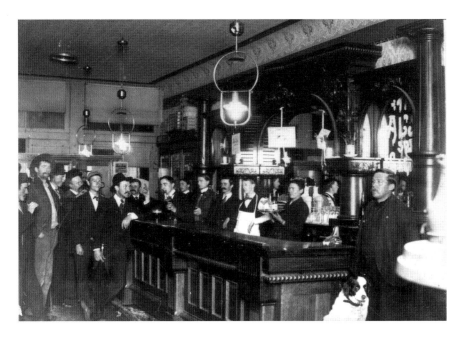

Patrons enjoying a drink in one of the many Cullman saloons during the late 1800s. *Cullman County Historical Society.*

beer, but the recipe was lost. For more than a century, no one knew it existed, until the recipe was rediscovered in 2014 and became the flagship beer for Cullman's first brewery since Prohibition, Goat Island Brewing. After Richter died in 1909, his son Albert "Al" Richter built Richter's Saloon, which would remain open until the start of Alabama's prohibition.

Cullman continues to celebrate its German heritage with the annual weeklong Cullman Oktoberfest.

THE ROAD TO PROHIBITION

In the early years of settling into the Alabama territory, liquor was commonplace and readily available. In addition to the breweries and saloons, other merchants sold copious amounts of whiskey, rum, wine and many other intoxicating beverages. Beer could be easily purchased from the local grocer or druggist. Home brewing and wine distilling were relatively common practices, especially on farms. Alcohol was simply a part of early American life. But with free-flowing alcoholic beverages came problems, and the colonies had to address the issues associated with the overabundance of liquor.

The family unit started to suffer, with drunkard fathers and husbands abusing their wives and children and men spending all of the family's money in saloons. Women had little recourse to protect themselves and their families from poverty and abuse because they had few rights and limited options to divorce their spouses.

Communities also suffered. Towns with a prominent saloon presence were often rowdy and violent. During the 1800s, the city of Decatur was an example of liquor usage run amuck. The city's location on the Tennessee River and the L&N Railroad made Decatur a prime location for sailors and other travelers looking for entertainment. They were a rough lot, and all matters of debauchery took place in the shabby saloons, brothels and gambling houses that lined the riverfront. It was so crime-ridden that a downtown alley behind the Bank Street businesses between Lafayette and Church Streets was nicknamed "Dead Man Alley" due to the frequency of

finding bodies there. The Lafayette Street Cemetery was across from the alley, and when it rained, broken whiskey and beer bottles would wash up from the cemetery into the streets.

The higher-class members of Decatur gave these murderous, violent places a wide berth, preferring to drink in the more subdued hotels and beer gardens in the downtown area. The more reputable drinking establishments included the Palace on Bank Street and the Bismark Hotel Bar. There was also a popular beer garden in the city.

There were also incidents of liquor fueling already volatile situations all across North Alabama, such as several horrific lynchings spawned from raging drunkards inciting violence and taking the law into their own hands. In one incident in 1900, a drunken mob in Huntsville lynched a young black man, Elijah Clark, accused of rape. According to the *Weekly Mercury*, the chief of police had all the saloons closed in a desperate attempt to minimize the drunkenness of the growing mob. After the saloons were closed, a great deal of drinking was done in private, and the inebriated crowd became violent and reckless. The sheriff was determined to protect his prisoner, so the mob burned tar, feathers and sulfur at the entrance of the jail to smoke the sheriff out and leave the accused rapist defenseless. When that did not work, the mob used dynamite to blow open the doors of the jail, storm it and drag the prisoner Clark from his cell in order to ruthlessly murder him. Drunken crowds were such a problem that Alabama had protocols in place to close saloons down when mob violence threatened to erupt, but this did not always prevent drunken men from causing bloodshed.

All these issues led to a call for liquor reform and alcohol restrictions. Concerned citizens started forming temperance groups to inspire people to avoid liquor. Alabama's first temperance society started in Tuscaloosa in 1828. Temperance activists were mostly concerned with keeping alcohol out the hands of the wrong sorts of people—minorities, the poverty stricken and immigrants. Eventually, the movement grew into a demand for total abstinence of alcohol for all people. Church members and women's groups banded together to form temperance organizations such as the Woman's Christian Temperance Union (WCTU) and the Anti-Saloon League.

Saloon owners and drinkers were slow to take the temperance groups seriously, thinking that the temperance movement was a phase and would blow over. Many saloon owners laughed and mocked the groups that stood or kneeled outside their saloons in protest, not realizing that the sentiment about the saloon was rapidly turning negative in the United States.

Women Prohibitionists

Because the ravages of alcohol abuse adversely affected women, they were at the forefront of the prohibition campaign. They lacked many rights, including the right to vote, and had no legal recourse to stop it, so they took to the streets and started protesting. All across the nation, women organized pray-ins, kneeling at the front of saloons and openly praying for the men inside. They begged saloon owners to close their doors and for patrons to stop drinking, and in many cases, these peaceful requests actually worked.

In the 1870s, groups of women protested across the country in thirty-one states and territories and managed to shut down 1,300 liquor dealers. Women suddenly discovered that by standing together they had the power to reshape society into a future they dreamed of. But the victories were short-lived and no laws had been changed, so it was not long before the saloons reopened and refilled with drinkers. The women knew that in order to accomplish their goal of eradicating alcohol from the United States, they would have to be organized and create official societies with focused objectives. One of the largest women's temperance groups was the Woman's Christian Temperance Union, which formed in Ohio in 1873. As the group grew, it created local chapters in every state. The members sought to protect the home from the ravages of liquor through "agitation, education, and legislation." They donned white ribbons to symbolize the purity of the cause and got to work changing the laws and hearts of drinking men. Members believed that through legal enforcement they would end the prevalence of liquor in their communities.

In 1874, at the WCTU's first convention, union members were encouraged to get their towns to install drinking fountains in parks and city centers. They reasoned that men would be less likely to enter liquor-peddling establishments for a drink of water if they had easy access to public water fountains. An example of such a fountain is in Gadsden, Alabama. The local chapter of the WCTU erected the fountain in 1928.

The fountain is inscribed with the names of several people who were responsible for its installment, including Mrs. Marietta Ward Sibert, who was responsible for contacting the national convention and getting a WCTU chapter started in Gadsden. Through continued vigilance, the ladies were able to close down all of Gadsden's saloons, as well as the Spoon Motlow Distillery plant. Although the fountain no longer provides water, it still stands in the Commons.

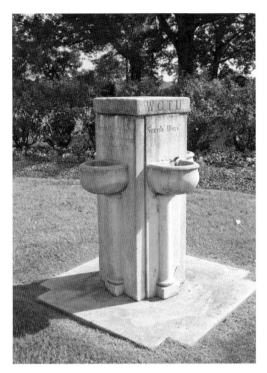

Left: A water fountain erected by the Woman's Christian Temperance Union in Guntersville, Alabama. The WCTU erected numerous fountains across the United States in order to encourage people to drink water rather than alcoholic beverages. *Photo by Sarah Bélanger.*

Below: Carrie Nation yelling at a crowd of men and boys on Huntsville's North Side Square. *Huntsville–Madison County Public Library.*

As the temperance movement grew, some members of the WCTU took a less restrained approach. There is no better example of this than one of the most colorful members of the WCTU, prohibitionist Carrie A. Nation. Nation had seen the deadly consequence of alcohol abuse when her first husband, Charles Gloyd, suffered from severe alcoholism and consequently died from it less than two years after they were married. Later in life, this experience caused her to become a vigilant, and often violent, opponent of the saloon and its devil whiskey. On June 7, 1900, she marched into Dobson's Saloon in Kiowa, Kansas, armed with several rocks and proclaimed, "Men, I have come to save you from a drunkard's fate." She then smashed the bottles of liquor with her rocks as a group of stunned saloon patrons watched in disbelief. This was the start of her destructive protests that would last for years and affect numerous saloons. As she continued rampaging saloons across the country, she started arming herself with a hatchet to more efficiently destroy these dens of sin. Carrie and her destructive hatchet became so well known in the United States that bars posted signs that said, "All Nations Welcome, Except Carrie Nation."

On October 25, 1902, Carrie Nation paid a visit to Huntsville to lecture on the evils of liquor and discuss her raids on saloons. She was so committed to her cause against alcohol that when she could not find a single hotel in Huntsville that didn't serve liquor, Nation resorted to staying in the home of Ms. Turner during her visit.

Nation spoke at the Huntsville Opera House, spreading her message of total abstinence to a large audience of teetotalers. By then, she had retired her iconic hatchet, relying instead on her fiery temperament and old-fashioned Bible thumping to get her message across. Throughout her lecture, Nation gripped her Bible and referenced it often. "She said she was serving God by raiding the joints and therefore had no fear," reported the *Huntsville Herald*. After her speech, Nation did manage to cause a slight ruckus by confronting saloon patrons throughout Huntsville, starting at the Dewdrop Saloon. Standing nearly six feet tall and not one to back down from a fight, she must have been a formidable figure to the saloon drinkers trying to enjoy their pints and shots. Next, she visited C.C. Baxter's Saloon. Mr. Baxter continued to serve drinks, and to the amusement of the patrons, Ms. Nation severely lectured one particular young man on the evils of liquor as he tried to enjoy his libation. She finished her visit of Huntsville at John Vairne's establishment. At that point, several hundred men, amused by the spectacle of Ms. Nation, were following her from saloon to saloon. She engaged Mr. Vairne in a spirited debate for several minutes but, frustrated by the mocking shouts of the growing crowd, demanded her driver take her away.

Wet versus Dry

Initially, the WCTU and other temperance groups across Alabama were concerned with educating the public about the dangers of liquor. They developed prohibition programs to instill the value of alcohol abstinence throughout schools and churches, but as the movement grew, the groups became more politically driven.

Churches of different denominations worked together to create a liquor-free state. Baptists, Methodists and Presbyterians were all fighting against Alabama saloons and liquor sellers. Their goal was not just to dissuade their parishioners from drinking but also to change the laws in order to fully snuff out the liquor industry. "Activated by the movement to prohibit the sale and use of alcoholic beverages, Alabama evangelicals, who had generally avoided controversial state politics earlier, mobilized to force adoption of their moral agenda in the 20th century," according to the Alabama Department of Archives & History. "They not only managed to force the state to adopt statewide prohibition, but also became involved on both sides of many other social reforms."

The Anti-Saloon League, one of the country's largest temperance groups, made it clear early on that its agenda was political by issuing a set of proposals calling for legislative change. In order to achieve its goals, the group proposed voting temperance-driven politicians into positions of power. The Alabama Chapter of the League printed fliers that said it wanted "to secure the nomination and election of such persons to the next General Assembly of Alabama as will pledge their support to a General Local Option Bill."

Although local option was not the total banishment of all liquor, prohibitionists considered it a step in the right direction. Up until this point, the state regulated saloons and liquor dealers by requiring them to buy liquor licenses. In order to keep the number of saloons down, licensing fees had risen, which meant only the most profitable or politically powerful saloons had the resources to stay open. This led to statewide corruption and monopolies in the liquor industry.

Local option legislation would allow each county in Alabama to vote either wet or dry. Prior to prohibition, the saloon-heavy cites preferred to be wet, while rural communities preferred to be dry. Cities relied more heavily on taxes to function, and residents had disposable income to spend at the saloons. On the other hand, rural communities were self-sufficient and less likely to understand the appeal of the saloon life. Statewide local option, while not ideal for prohibitionists, would allow the rural counties to vote dry.

Prior to the call for a local option bill, some cities had already taken it upon themselves to ban liquor and saloons, with successful results.

As the Anti-Saloon League grew in numbers and influence, more temperance-supporting politicians were voted into important offices. Laws were starting to favor prohibition.

Some of the first liquor-regulating legislation that the prohibitionists passed during the 1898–99 session was to create a government-run dispensary system. Senator Frank S. Moody from Tuscaloosa sponsored the bill, which proposed a government dispensary system that would regulate how liquor was sold in the state. The objective was to take the control of the liquor trade out of the hands of greedy, booze-pushing private citizens and put it in the hands of the responsible, liquor-limiting government. The Alabama-run dispensaries would adhere to mandated hours of operation and be restricted on the types and amounts of liquor sold. All liquor legally sold in Alabama would be purchased through the dispensaries and be taxed. The number of government-controlled dispensaries was also limited in order to cut back on the amount of liquor available to the consumer. Again, prohibitionists saw this law as a step toward their ultimate goal of total prohibition.

But the changing laws had done nothing to unify how the state handled liquor sales and distribution. By 1907, twenty-one counties were completely dry, twenty-one had licensed saloons, sixteen had only government-sponsored dispensaries and nine had both licensed saloons and dispensaries. Despite the dispensary laws, Alabama breweries managed to stay open. From 1900 to 1908, five breweries operated in the state at varying degrees of success. Surprisingly, the restricting laws did not curb beer production, and Alabama had its most successful year to date in 1907 with nearly 115,000 barrels of beer produced.

The politicized prohibitionists wanted big changes. These changes would end up altering the drinking habits of Alabamians for generations, and not necessarily in a way the teetotalers hoped for: during Prohibition, lighter drinks such as beer and wine would be replaced with stronger, illicit drinks such as moonshine and whiskey. The ultimate goal of the Alabama prohibitionists was to pass an amendment that would enact a statewide ban on all liquor. Temperance groups, churches and women worked together to reeducate the public and make it clear to the politicians that statewide prohibition was in the best interest of the voting citizens. During a special session in November 1908, the Alabama state legislature passed the Carmichael State Prohibition Law, which prohibited the sale of liquor or intoxicating beverages in the state. The ban was so stringent that it would

be called the "bone-dry law." Prohibitionists were victorious. Feeling like they had made history by ending liquor in Alabama forever, the WCTU preserved the golden pen that Governor B.B. Comer used to sign statewide prohibition into law.

Although the temperance groups and other prohibitionists celebrated their victory, they would be disappointed, as the law would soon be overturned. The tax revenue produced from liquor and saloon licensing had been indispensable to Alabama's state budget. To make up for the loss of liquor revenue, the state had to increase licensing fees and taxes in other industries. Some unlucky businesses saw their fees double or even quadruple. And businesses that had not been required to pay fees before—such as candy makers, coal agents and furniture manufacturers—suddenly had to pay for the first time.

The United States Beverage Association published a pamphlet in 1909 illustrating the tax struggles Alabama was dealing with. "The liquor business has always been heavily taxed in these cities, and when this large revenue was lost, it seemed that the only means of meeting the deficit was to materially increase the merchants' tax and to place a tax upon a large number of occupations, which were never before required to take out a license at all," said pamphlet author Reed Carradine.

Additionally, no system had been put in place to enforce the laws, so moonshiners and illegal saloons called "blind tigers" were running rampant. Some saloons changed to legal near-beer saloons, which in theory sold non-alcoholic beer but in reality often sold illegal alcoholic beer or stronger liquor to known patrons.

In 1911, an article by R.E. Pritchard in *Harper's Weekly* magazine criticized the South's attempt at prohibition: "Prohibition in the South is a failure, not only because it does not prohibit, but because it is breeding a defiance of law and has set up in the place of licensed saloons illegal dispensaries of liquor."

Alabama's first attempt at prohibition ended in 1911, and once again dispensaries became the favored way to regulate liquor sales in the state.

While Alabama was deciding how to deal with alcohol, the United States was tackling the issue on a national scale. Many people felt that liquor should be outlawed in the United States, but like Alabama, the national government relied heavily on the income produced from saloon licensing fees and liquor tax. Losing this revenue would severely limit the government's ability to function.

This changed in 1913 when the Sixteenth Amendment to the Constitution was adopted, allowing the federal government to collect taxes on income. The

taxes would be used to fund the military and build bridges and roads, as well as for other essential programs, thus ending the dependence on liquor revenue. Alabama was the first state to ratify the amendment.

In 1914, following a lawsuit, Alabama's dispensaries were found to be violating monopoly laws and were ruled illegal. It seemed like Alabama would go back to local option, but the prohibitionists were fighting for total prohibition. They continued to push their agenda in schools. On March 5, 1915, all of the state's public schools observed Temperance Day. The day was set up to "give instructions as to the nature of alcoholic drinks, tobacco and other narcotics, and the effects upon the human system, and such subject shall be taught as regularly as any other in the public school." Some of the education was dubious at best, including the warning that even one drink of alcohol could cause a person to spontaneously combust into blue flames.

The WCTU published numerous anti-drinking advertisements. The advertisements were used to illustrate the ravages of alcohol on the family and show how prohibition could be successful, even profitable, for the country. They stated that the people who suffered the most from alcohol were women, children and the poor. The *Florence Times* had weekly columns condemning liquor called "Temperance Notes" sponsored by the local chapter of the WCTU. One of the ads claimed that in Mexico, "most cases of epilepsy are caused by drunkenness" and urged the government to put an end to liquor in the United States. Some of the advertisements were pleading, while others were quite forceful. "The president of a people might not be a drinker himself, but so long as he permits his people to play with poison, he is himself a weakling."

With the financial burden of tax loss diminished thanks to the creation of the federal income tax, prohibitionists once again pushed for statewide prohibition. The bill came to a vote at the time that prohibitionist governor Emmett O'Neal was leaving office. Prohibitionists had hoped that the governor would push the law through before the end of his term, but he left it for the incumbent governor, Charles Henderson, who favored local option. Governor Henderson immediately vetoed the bill, but the majority of legislators were prohibitionists and easily passed the bill into law on July 1, 1915, despite his veto. Once again, statewide prohibition was the law of the land in Alabama. Four years later, the United States of America would go dry as well.

On January 16, 1919, after years of debating, protesting and fighting, the United States ratified the Eighteenth Amendment, which made it illegal to produce, sell or distribute intoxicating beverages. The amendment

would go in effect one year later in January 1920. In order to enforce the amendment, the National Prohibition Act, or Volstead Act, was enacted to define what constituted an intoxicating beverage, as well as determine the punishment for breaking the law. The Volstead Act was severe. It defined intoxicating liquor as any beverage that contained more than 0.5 percent alcohol. Even light beer was illegal to manufacture, purchase or sell. There were some exceptions to the amendment that allowed individuals to make small amounts of alcohol, but they applied to wine and cider, not beer. Beer, a beverage once credited with sustaining the Pilgrims on their long voyage across the Atlantic Ocean, was now illegal.

No amendment had ever been overturned in the history of the Constitution, so when the Eighteenth Amendment was enacted, prohibitionists thought that liquor was an issue they could finally put behind them. They would be proven wrong.

ALABAMA PROHIBITION

Initially, prohibition seemed to be working in Alabama. In 1918, the *Montgomery Journal* reported almost empty prisons, and the sheriff of Montgomery County said that he was considering renting the empty jail out since he didn't know what else to do with it. Alcohol-related crimes and incidents of public intoxication seemed to have gone down. But the calm was short-lived, and problems soon arose. The desire to drink did not go away when alcoholic beverages became illegal. The liquor trade simply went underground. Distillers became moonshiners, liquor sellers became bootleggers and patrons became lawbreakers. Moonshiners and bootleggers discovered the illegal liquor trade to be a lucrative business. Corrupt law enforcement agents, lawyers and politicians found their wallets fuller from bribes, and honest police officers had to fight against more corruption and violence after the illegal liquor trade became profitable.

BOOTLEGGERS AND MOONSHINERS

Once liquor became illegal, people came up with many innovative ways to sell and distribute it. One way was to keep a flask of hard spirits hidden in the leg of a person's tall boot and charge customers a fee for a swig out of the flask—hence the term "bootlegger." The term would eventually mean anyone who manufactured, sold or distributed illegal alcohol.

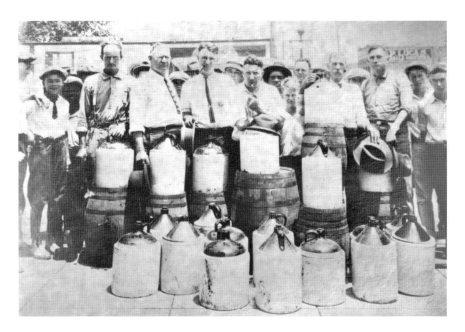

Men posing with contraband confiscated from a moonshine raid in Florence, Alabama, during Prohibition. *Florence-Lauderdale Public Library.*

For as long as there have been liquor laws, there have been bootleggers breaking those laws. Even before prohibition, bootleggers existed. From 1876 until 1881, well before statewide prohibition, 268 stills were shut down and 949 people were arrested for illegal liquor trade in Alabama. Once prohibition was in full swing, these numbers would go up drastically.

North Alabama was a particularly hard place to stop the illegal liquor trade due to the prevalence of steamboats, trains and wild terrain, all of which made it easy to transport and hide illegal booze. The rural areas were perfect for moonshiners to set up stills and remain relatively undisturbed by law enforcement agents.

Illegal moonshining brought with it a multitude of problems. Many moonshiners were not concerned with the quality of their product. Because it was illegal, there was no regulation on how the liquor was produced, and unscrupulous moonshiners would use the quickest and cheapest techniques possible. Some moonshiners would distill the liquor in a truck radiator, which could give the drinker lead poisoning. If consumers were not careful, they risked not only arrest but also death. In the United States during Prohibition, approximately one thousand people died each year from drinking tainted liquor.

There were also cases of moonshiners hiring children to help make the liquor. In 1935, Eugene Connor, Jefferson County chairman of the Alabama League for Prohibition, claimed that children as young as eight years old were paid to collect pine knots to keep illegal still fires burning or carry buckets of water for liquor production. Initially, the moonshiners paid the minors ten to fifty cents a day, but over time, they started paying them in liquor, which had a detrimental effect. "I have seen more minors in the country villages under the influence of liquor than grown people in cities," said Connor.

Moonshiners often clashed with local law enforcement agents, sometimes with deadly consequences. Once such incident occurred in Cullman in 1919. Sheriff John W. Sparks had only been in the position for six months when he was sent to arrest a suspected moonshiner. He arrived at the suspect's residence and was refused entrance, so he attempted to get in with force. The moonshiner was armed, and both men shot at each other at the same time. The suspect was instantly killed, and Sheriff Sparks was mortally wounded. Sparks staggered to a local drugstore but died before he could get help. He would be Cullman's first and only sheriff to die in the line of duty.

The fear of violent moonshiners and bootleggers made some police officers reckless and trigger-happy. In Montgomery County, two law enforcement officers pursued and shot at a car that they suspected housed bootleggers transporting liquor, but it was actually two female schoolteachers not connected to the illegal liquor trade. "Such incidents stirred a public disapproval and distrust which helped swell the tide of sentiment running strongly against the prohibition laws," said Prohibition historian James Benson Sellers.

One long-term effect of illegal moonshining was a change in people's alcohol preferences. Beer had been popular before Prohibition, but it has a complicated brewing process that, if done incorrectly, leads to bad beer. It also has lower alcohol content, so a larger quantity has to be consumed to get inebriated. Illegal liquor dealers were not likely to risk arrest for an alcoholic beverage that is complicated to make and has a lower profit margin. Because of the lack of access to beer, drinkers started preferring the stronger stuff that would get them drunk faster. Even after Prohibition, hard liquor and sugary sodas would remain more popular than beer for decades to come.

People who wanted to drink liquor found ways to circumvent the law, whether it was by making their own liquor, finding illegal saloons or taking advantage of loopholes in the laws.

BLIND TIGERS

Because there were fewer legal places to drink, numerous illicit saloons called "blind tigers" opened. The name "blind tiger" or "blind pig" came from the practice of illegal saloons charging a fee to view a curiosity, such as a blind tiger, which would include a "free" drink. Sometimes the tiger was nothing more than a taxidermic animal with a blindfold over its eyes. This tactic was a way to circumvent the law. Blind tigers quickly became a general term for an unlicensed saloon selling illegal liquor. Unlike licensed saloons, which had an incentive to pay licensing fees and follow the rules to stay in business, blind tigers made up their own rules. They were often places to drink heavily, gamble and meet with prostitutes. When a blind tiger was raided and shut down, the owner would usually just pay a fine and reopen his illegal saloon a short time later.

STEAMBOATS

The Tennessee River cuts across the top half of North Alabama, while the Coosa River and Black Warrior River cover the lower half. This made it possible for steamboats to conveniently transport illicit booze throughout the region. During Prohibition, steamboats ran liquor from larger river cities, such as Chattanooga, down to North Alabama. Many illegal businesses had tunnels underneath them that went straight to the river, making it easy to covertly transport shipments of whiskey and other intoxicating beverages from ships. Evidence of the illegal trade can still be found in various cities.

In 2014, David Armistead started renovating his shop in downtown Decatur, the Tennessee Valley Pecan Company, and found a hidden tunnel underneath it. After some investigation, and with the help of local historians, he was able to determine that the tunnel was used to hide illegal liquor during Prohibition. In the tunnel, he found broken whiskey bottles and brittle cardboard boxes from the 1930s, one with a label for Cook's Beer. He loved the history of the tunnel so much that he left it untouched and placed glass over the entrance so people could look down into it and sneak a peak into the illegal liquor trade during Prohibition.

Some steamboats set themselves up as blind tigers, charging patrons a fee for entertainment and then serving "free" liquor. One example of this was in Etowah County, where steamboats serving liquor floated up

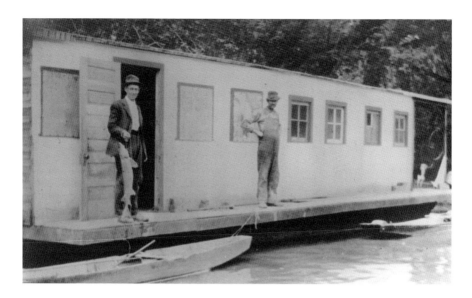

Above: A boat on the Coosa River during Prohibition. Boats similar to this one transported illegal liquor from Tennessee. *Etowah Historical Society.*

Right: In 2014, David Armistead found a secret Prohibition-era tunnel underneath his shop, the Tennessee Valley Pecan Company. The tunnel likely extended to the Tennessee River and was used to transport illegal shipments of liquor from boats. *Photo by Sarah Bélanger.*

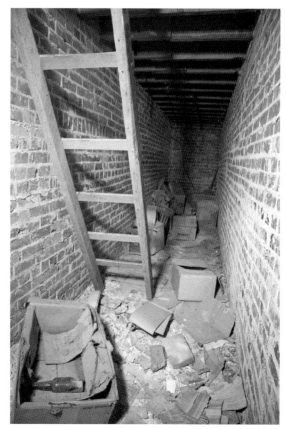

and down the Coosa River. Some patrons would become so drunk that steamboat captains would have to string ropes all around the boat deck to keep their increasingly unsteady passengers from falling overboard.

Because Alabama's waterways were not under the same jurisdiction as the land, boats could technically serve liquor freely and were only breaking the law once they docked. The boats would anchor near bridges and ferry crossings to make it convenient for the public to reach them in small rowboats—and hard for the police to catch them. If the authorities got too close to the steamboat, it would simply move to another location.

LOCKER CLUBS

Despite what prohibitionists professed, it was not just the hardened criminal and uneducated man who enjoyed illegal liquor. Many of North Alabama's elite joined Locker Clubs, which were another way to bypass the law. Locker Clubs did not sell liquor; they sold club "memberships." Members would then be given a locker, which was filled with liquor. Since it was not illegal to drink alcohol—only manufacture, sell and buy it—the Locker Clubs were able to skirt around the law.

REDSTONE ARSENAL

People wanting liquor during Prohibition relied on creative means to get their hands on it. In the dry days of Huntsville, Redstone Arsenal employees would steal pure grain alcohol, which was housed in large quantities on the base. The less creative smugglers would fill flasks with alcohol and sneak them off the arsenal. Base guards did random searches, so this was a good way to get caught. The more inventive smugglers filled their cars' radiators with alcohol and simply drove past security. To combat the alcohol theft, base guards started vehicle searches. It was easy to identify the cars with alcohol in their radiators because after a few minutes of waiting in line, the car would start to steam.

Political Corruption

Political corruption was certainly not a new concept in Alabama. A county clerk might sneak a little money from the till or a police officer might accept some hush money to ignore a crime, but the illegal liquor trade made political corruption extremely profitable and, for many, worth the risk. One of the most prominent and dramatic examples of liquor-driven political corruption in Alabama occurred in Huntsville in 1916, just one year after statewide prohibition had been enacted.

Police Chief David Overton had been smuggling liquor into the city using his officers and vehicles to conceal the illegal whiskey coming from Tennessee. The scheme started unraveling when Overton decided to run for probate judge against the incumbent, prohibitionist Judge William T. Lawler. The campaign on both sides was dirty, with allegations of voter fraud, slandering and even planting illegal liquor on each other's properties. In the end, Judge Lawler won the race. The people of Huntsville thought teetotaler Lawler would put a stop to Overton's illicit liquor trade, but six weeks after the election, the judge was found dead, shot through the heart and with a crushed skull, submerged in the Tennessee River. Suspiciously, Overton was missing. People assumed that Overton would be found and the case would be closed quickly, but it was much more complicated than that.

Judge Lawler's death would bring to light Overton's illegal liquor trade and would incriminate many prominent Huntsville citizens, as well as the Huntsville Police Department. Three days after Lawler's body was found, current sheriff Robert Phillips shot himself in the head. He had not been suspected of being involved, but his suicide note stated that he was worried people would think he was. While on trial, Overton did claim that Sheriff Phillips had helped him hide Lawler's body. Three days after Phillips's suicide, prominent lawyer Shelby Pleasant also suspiciously killed himself. Then Chief of Police A.D. Kirby resigned after he was accused by a grand jury of using a taxicab line to haul illegal whiskey.

Eventually, Overton was caught in Tennessee two months after going on the run. He was brought back to Alabama for trial but pleaded innocent. Throughout the trial, Overton claimed that he had a big secret that would clear him of all charges, but as the trial came to an end, Overton got on the stand and confessed to the murder. He was found guilty and sentenced to hang. The case seemed to be over, but in a final twist, while awaiting his sentence in Birmingham, Overton escaped from prison with six other convicts. They fled in a car that was parked just outside the prison, but the

police gave them chase. After a shootout, two prisoners were dead, including David Overton. There was much speculation about whether the escape had been a setup in order to assassinate Overton before he revealed too much about who else was involved in Huntsville's illegal liquor trade.

THE END OF ALABAMA PROHIBITION

Although Prohibition did put an end to the rough days of the saloon, it also brought with it an increase in crime and a decrease in revenue. It criminalized many otherwise law-abiding citizens and forced the liquor industry underground away from the rules that could keep it regulated.

Despite all the violence and corruption that Prohibition had brought to the state, it would be the almighty dollar that finally put an end to it. In 1929, the stock market crashed, and by the early 1930s, the Great Depression was in full swing. People were more concerned with feeding and housing their families than keeping alcohol out of the hands of drunkards. Both the state and federal governments were desperate for tax revenue, and before Prohibition, liquor had been a great way to generate it.

During Prohibition, Alabama's "bone-dry laws" were so stringent that even the slightest amount of alcohol was illegal. Several attempts had been made to legalize "non-intoxicating cereal beverage," which was a grain-infused drink containing less than 0.5 percent of alcohol. The cereal beverage was said to have health benefits, but prohibitionists rigidly refused to accept even this small amount of alcohol and consistently voted the bill down. In 1932, the Alabama House finally passed the bill, which staunch prohibitionist governor Benjamin M. Miller promptly vetoed. The House was able to pass the bill with a majority vote, and it then easily passed the Senate. This was the first sign that legal liquor might come back to Alabama, but it would still be a hard fight.

At the same time that Alabama voted to allow 0.5 percent alcohol in drinks, the United States was looking to end Prohibition. Liquor laws had taken center stage during the 1932 U.S. presidential election. Franklin D. Roosevelt had run and won the election on the platform to repeal the Eighteenth Amendment. On March 22, 1933, less than a month after being in office, President Roosevelt signed the Cullen-Harrison Act, or the Beer Bill, which legalized the sale of beer with less than 3.2 percent alcohol. After signing the bill, Roosevelt joked, "I think this would be a good time for a

beer." Legalizing beer was the beginning of the end for federal Prohibition. And it would be a quick end.

Less than a year later, on December 5, 1933, the United States did something it had never done before: repealed a constitutional amendment. Almost fourteen years after it began, Prohibition ended with the ratification of the Twenty-First Amendment, which federally re-legalized liquor. Going forward, it would be up to each of the states to decide if they wanted to legalize liquor. Conservative Alabama would choose to remain dry.

But dry Alabama would be plagued with financial issues. In 1935, the education fund was inadequate for the public schools to remain open for the next academic year. Money would need to come quickly, and it was proposed that taxed liquor sales would create enough money to keep the schools open. Despite being a prohibitionist, Governor Bibb Graves called legislation to a special session in February 1936 to discuss legalizing liquor. Governor Graves stated that to fund schools the legislature needed to either re-legalize liquor or create a sales tax. The politicians were divided, and both wets and drys fought vehemently for their cause. During one particularly heated debate, Senators J. Miller Bonner and Tom Frazer decided that the best way to solve their differences was to fight it out like men with their fists. Other senators broke them apart, but it still took twenty minutes to calm everyone down to proceed with the session. In the end, no progress was made, and no bill was passed. When the education money ran out, most county schools closed five to seven months into the 1936 academic year.

Another year went by, and the education fund was still inadequate. Once again, the state would not be able to keep the schools open for the entire school year.

In November 1937, Governor Graves once again proposed legalizing liquor, but because Alabama had consistently voted to maintain its prohibition, he was careful in how he re-presented the bill. He proposed that the state create the office of Alcoholic Beverage Control Board (ABC Board) to strictly regulate how liquor and malt beverages were manufactured, transported, possessed and sold. He also proposed reinstating local option so that counties could vote if they wanted to be wet or dry. Although there was still much debate and concern about the bill, the schools needed money, and the politicians voted the bill into law, thus creating the ABC Board.

Although alcoholic beverages were once again legal, the liquor industry was under governmental scrutiny and numerous restrictions in order to ensure that the wild days of the saloon would not come back. The local option provision meant that the residents would vote for their county to

be wet or dry, and the ABC Board strictly regulated the wet counties. Businesses had to have proper licensing and follow all rules created by the newly formed government agency. Additionally, the beer industry had to adhere to a three-tier system. This meant that breweries could not sell directly to a retailer; instead, they had to hire an independent distributor to transport and market their product. The idea behind this regulation was to limit the potentially abusive powers of large breweries, which could force a retailer to only sell their beer and thus create a monopoly. This had been a problem before Prohibition. The three-tier system also meant that the government could collect more taxes on the beer. Even in 2015, the State of Alabama taxed beer the third most in the country compared to other states.

As the time came for counties to vote to allow liquor, prohibitionist groups organized demonstrations to persuade communities to vote dry. Churches held coordinated prayer meetings on March 8, 1937, two days before each county would cast their vote. Despite the prohibitionists' best efforts, twenty-four counties voted wet, while forty-three remained dry. Although only one-third of the counties voted wet, those counties housed more than 50 percent of the state's population.

On May 5, 1937, Montgomery opened the state's first liquor store since before Prohibition, and liquor was legally sold in Alabama for the first time since 1915. Birmingham and Mobile opened their stores two days later. Statewide prohibition was officially over in Alabama.

BREWPUB ERA

When prohibition ended in Alabama, numerous laws were put in place to prevent the saloon, with its violence and debauchery, from coming back. These laws were under the jurisdiction of the newly formed ABC Board, which had been created to regulate and restrict liquor usage in Alabama. According to its website, its goal was, and still is, to produce "high revenue with low consumption."

Politically and morally, all alcohol, including beer, continued to be a hot-button issue for the state. Alabama's restrictive legislations and conservative values had not just ended the wild saloon days; they also killed the craft beer industry. Even fifty-five years after the end of Prohibition, beer selection in the state was extremely limited, and its production was practically impossible.

Indeed, while the state progressed, the laws did not, and very little liquor legislation had been updated since 1937. Since the end of statewide prohibition, Alabama continued to rely on local option legislation, allowing each county to choose to be wet or dry. In wet areas, the ABC Board issued liquor licenses, conducted audits, enforced the law, collected taxes and disbursed funds. Also regulating how beer, wine and distilled spirits were transported and sold was a three-tier system. In the beer industry, the three tiers were composed of a brewery at Tier 1, an independent distributor at Tier 2 and a retailer at Tier 3. With this system, a manufacturer has to have a contract with an independent distributor who markets a brewery's beer and transports it to a retailer. Once a brewery signs a contract with a distributor, the contract is for life, and the brewery has limited recourse to

get out of it. The three-tier system was created at the end of Prohibition by the federal government and was intended to prevent massive breweries from having too much unregulated power over how the beer industry functioned. However, this system has been a hardship for some of the smaller breweries.

Furthermore, the beer industry was under additional archaic restrictions, most likely due to people's perception that beer is a blue-collar beverage, and a fear of the return of the saloon. Some of these restrictions included beer being limited to 6 percent alcohol and a sixteen-ounce container size, despite wine and hard spirits not having to adhere to these strict guidelines. Under the Prohibition-era legislation, microbreweries were also banned from having taprooms, selling their beer on site or offering samples to patrons. Beer is a difficult and expensive product to brew with a slim profit margin, and these additional laws were effective in severely stifling Alabama's brewing industry.

Over the decades after Prohibition ended, the federal government modernized brewing laws. In 1978, President Jimmy Carter legalized home brewing, and much of the United States experienced a renewed interest in craft beer. But despite the federal change, Alabama remained firmly against the craft beer industry, showing little inclination to change its 1937 restrictions on home brewing or local beer manufacturing.

Some small changes did occur at the state level, such as in 1980 when Alabama passed the Keg Beer law, which allowed wet counties to sell draft beer without getting special approval from the ABC Board. This did very little to encourage manufacturing.

But in 1992, Alabama passed the Brewpub Act and took a tiny step toward creating a craft beer industry. The Brewpub Act allowed brewers to make beer and sell it on site without having to pay for an independent distributor. But the act had a lot of restrictions. Because brewpubs had not legally existed in Alabama since 1915, new legislation had to be created to accommodate a single license that allowed for both the manufacturing and the sale of beer in the same location. In an effort to get the law passed, numerous restrictions were placed on the brewpubs. Brewpubs could only be in counties that had allowed brewing prior to the start of national Prohibition in 1920. This restriction meant that only eleven counties out of the sixty-seven could have a brewpub. Brewpubs also had to be located in a registered historic building and operate an eighty-seat restaurant on the premises. Brewpubs could not sell their beer off site or make more than ten thousand gallons of it in a year. All of these restrictions made it hard to make a profit, but several entrepreneurs tried anyway. Birmingham was the first to take the leap, opening several brewpubs in the early 1990s—including

Birmingham Brewing and the Mill Bakery, Eatery and Brewery—but the legally confining environment made it hard to thrive, and eventually each location closed.

Although the 1992 Brewpub Act did not stimulate the craft beer industry as was hoped, it wet Alabama's whistle with local craft beer and started a slow-growing desire for more. Twelve years later, a movement would begin and change people's perceptions about beer in Alabama. Soon people would see it was possible for locally produced beer to succeed in the Deep South and even become a thriving industry.

THE FREE THE HOPS ERA

With the longest constitution in the United States, Alabama has some of the most complex laws and regulations, especially when it comes to liquor. Although national Prohibition ended in 1933, Alabama maintained many of its temperance laws into the twenty-first century. The economy was a factor in loosening these beer laws, but ultimately it was a devoted group of beer lovers fighting for a better beer selection that ignited a spark that would start a craft beer revolution in the state.

In 2004, a limited beer selection left Alabamian Danner Kline scratching his head. Danner had developed his love for craft beer in Alabama, but on a trip to Texas, he was exposed to beer with alcohol that exceeded a 6 percent limit. "That was when I had my first barley wine, my first double IPA and my first imperial stout," said Danner.

When he got back to his home state the stronger brews weren't available, so he started researching why. He found that Alabama had some of the most restrictive beer laws in the nation, which included a limit of alcohol by volume and container size. Patrons visiting breweries could not consume or purchase beer on premises, and brewpubs were required to be located in historic sites and in counties where beer was commercially brewed before Prohibition.

"After that Texas trip, I became obsessed with craft beer, and with the laws that prevented me from having access to the variety that most of the rest of the country had," said Danner. So, with several other beer aficionados, he began the grassroots nonprofit organization Free the Hops. "That trip

flipped a switch inside of me and directly led to the creation of Free the Hops in the fall of '04," he said.

Danner formed the group after studying how other states dealt with loosening restrictive beer laws, and he learned that he was in for a fight. "I'd talked to people in both Georgia and North Carolina who'd worked on similar efforts, so I had a very good idea of what to expect, and those expectations turned out to be pretty accurate," said Danner. He was warned about "opposition from religious conservatives, opposition from a majority of beer wholesalers, misunderstandings from the general public and among legislators about the nature of the products we wanted to legalize." He was also warned it may take several years to see change happen.

Free the Hops had three legislative goals: increase beer's alcohol by volume (ABV), create a more financially viable environment for breweries and brewpubs and increase the container size from sixteen ounces to at least twenty-eight ounces. These laws would not only increase the styles of beer available in the state but also create a better environment to start a local brewery.

In order to accomplish these goals, Free the Hops would have to increase its membership. Word about the newly formed group was spread through several venues. The home brewing store Alabrew advertised Free the Hops in its newsletter, and the restaurant J. Clyde featured informational table toppers, pamphlets and beer dinners to educate the public and encourage them to join the group. Free the Hops' membership steadily grew, and the organization became active as a lobbyist group. In 2004, Danner met Harry Kampakis, the owner of Birmingham Beverage, which would later become a wholesale distributor and a beer and liquor importer. Harry had wanted Alabama's beer laws to change for years, and when he met Danner, he realized they shared a vision for an Alabama with more diverse beer. They started working closely together to make this happen.

In 2005, knowing that they needed the support of the governor to pass any beer legislation, Harry arranged a meeting between himself, Danner and then governor Bob Riley. "Harry won the opportunity for a meal for two with the governor at a charity auction," said Danner. "He chose to take me with him (as opposed to his wife, ha!) because raising the ABV limit was so important to him and he wanted to get the governor's support."

After presenting their case, Governor Riley replied, "Well, I tell you what, you get that legislation to my desk, and mind you, I don't believe you can, but if you do, I will not oppose it." Harry arranged for lobbyist and childhood friend Michael Sullivan to represent Free the Hops and agreed to pay for

the lobbyist himself until the newly formed organization could fundraise enough money to take over the lobbyist's expenses.

In October 2005, Danner was interviewed on Comedy Central's *The Daily Show* and was asked what adding a larger beer selection would do for the state of Alabama. Kline answered that he believed it would improve the image of the state, make Alabama a more desirable tourist destination and increase tax revenue, but many didn't share his vision.

As was predicted, Free the Hops encountered opposition. In January 2006, the executive director of the Alabama Citizens Action Program (ALCAP), Dan Ireland, spoke against Alabama raising the ABV of beer. ALCAP is the self-proclaimed "moral compass" of Alabama, an organization that works to influence state legislators in order to create laws that align with their moral views. ALCAP takes a strong stance on prohibiting all types of alcohol.

"It's ridiculous to even think about putting a beverage on the market with that high level of alcohol that teenagers want to buy," said Ireland. When asked about the fact that the law already allows wine twice as strong, Ireland responded, "Beer is the beverage of choice, not wine. Kids are not going out and buying wine." Danner countered that "beer is not the beverage of choice for kids, cheap beer is the beverage of choice for kids."

Further opposition was found in the Alabama House of Representatives. During the debate for the 2007 Budget Isolation Resolution (BIR) vote, representatives made arguments against the Gourmet Beer Bill, a bill created to increase beer's ABV higher than 6 percent. The politicians illustrated that they did not fully understand the craft beer industry when State Representative DuWayne Bridges argued that more alcohol in beer would result in 60 or 80 percent more traffic-related fatalities. Another argument, presented by State Representative Richard Laird, was that the bill would allow beer "maybe as high as 80 percent [alcohol] content." Neither argument turned out to be true.

In 2007, eight bills (three House and five Senate) to raise the ABV were defeated. Alabama legislators have a quirky tradition of presenting a satirical award for the deadest bill called the Shroud Award. The prize is a black suit mounted on a piece of cardboard and is presented to the bill that is the least likely to make it into law. That year, it was presented to beer bill 195, one of the eight bills that failed. Even though it might be perceived as a bad sign for the craft beer industry in Alabama, one benefit was that it brought more publicity to the cause. "It gets us a little press as the session comes to a close," said Danner. While Bill 195 did not pass, it failed by only three votes. This proved that Free the Hops had been successful in

educating the public and politicians on their issue. The movement was gaining traction.

Throughout the 2007 and 2008 legislative sessions, Free the Hops faced opposition from the leadership of Birmingham Budweiser, a local Anheuser-Busch distributor. According to Free the Hops president Stuart Carter, leadership at Birmingham Budweiser had been actively lobbying against the Gourmet Beer Bill. If the bill passed, numerous previously illegal specialty beers would flood into the market, thus increasing competition. Carter e-mailed the Free the Hops members encouraging a formal boycott of Birmingham Budweiser products. Anheuser-Busch, the actual brewery, learned of the boycott and pressured its distributors to end lobbying against the bill and prevent bad publicity with its brand. Members of Free the Hops felt this helped them get a deal with the distributors, and the bill eventually passed in 2009.

In 2008, the craft beer movement in Alabama started attracting national attention with several articles in national newspapers. One article got home brewer and Free the Hops member Scott Oberman into a bit of trouble. As of 2008, home brewing was still illegal in Alabama; despite this, Huntsville had a home brewing club, Rocket City Brewers, whose members had been illegally home brewing since the 1980s. Scott joined the group in 1998 and initially did not even realize that home brewing was illegal in the state. He had been in the group for two or three years before the illegality of home brewing was ever mentioned and none of the members had ever heard of the laws being enforced, so they did not worry about it. Even so, the members did not advertise the group's activities.

As Free the Hops started its campaign to increase the availability of different beers, members of Rocket City Brewers decided that they wanted to get home brewing legalized. They formed the group Right to Brew, and like Free the Hops, they worked to reeducate the public and change archaic home brewing laws.

In 2008, the *Los Angeles Times* contacted Scott to do a story about illegal home brewing in Alabama. He agreed to do the interview, excited that their struggle would get national coverage. "We wanted to get the word out about home brewing in a reasonable and respectable way and show it in a positive light," said Scott. Unfortunately, his article attracted the attention of the ABC Board. After the article went viral, Scott found a handwritten note on his mailbox telling him to contact his local ABC Board. At first he thought it was a practical joke from one of his fellow brewers, but just in case, he followed through on the request.

It was not a joke. Scott had to meet with an ABC Board agent and sign a paper informing him of the illegality of home brewing in Alabama. The experience left him shaken. He had a job with a security clearance and also was going through a divorce and had joint custody of his daughter, so he was concerned for both his livelihood and family. Scott immediately moved his home brewing paraphernalia out of his house. The owners of Olde Towne Brewing Company let him keep his equipment in their facilities so he could continue to home brew. Scott was even more determined to change the laws and continue his work with Right to Brew.

Danner noted that when he started Free the Hops in 2004, there were five states that prohibited beer with ABV over 6 percent, but by 2009, there were only two states: Mississippi and Alabama. Free the Hops had been fighting for five years to change the laws. Danner said that the biggest opposition had not come from "neo-prohibitionists or mega-breweries desperately clinging to an extra point of market-share— it has been the dysfunctional Alabama Senate that simply won't pass bills."

But in May 2009, Free the Hops could finally celebrate a major victory with the passing of the Gourmet Beer Bill, which raised the ABV from 6 percent to 13.9 percent. The first goal of Free the Hops had been accomplished, but there was still more to do.

Working in conjunction with Free the Hops was the Alabama Brewers Guild. Its purpose was to build a favorable environment for the craft beer industry to flourish in Alabama through education and legislation. The group's members were mostly professional brewers who were fighting against laws that had stifled their industry for decades.

Free the Hops and the Alabama Brewers Guild decided to tackle restrictions on breweries and brewpubs next, in part because an election year was coming up and helping breweries be more functional was simply helping small businesses. Most voters would get behind a politician helping small businesses but not necessarily a politician working to increase beer selection.

The second bill, which was signed into law in June 2011, was the Brewery Modernization Act. The goal of the bill was to create an environment that made it easier and more profitable to operate a brewery or brewpub in Alabama. Before the Brewery Modernization Act, taprooms were illegal in Alabama's distributing breweries. In order to buy or even sip a beer from a local brewery, the beer had to be sold from the brewery to a distributor and then to a retailer, and then finally the customer could buy it. The Brewery Modernization Act allowed breweries to serve their own beer on site in taprooms just like a brewpub.

The bill also removed numerous restrictions that had been holding back brewpubs. After the bill passed, brewpubs no longer needed to have an attached eighty-seat restaurant; although they still needed to serve food, it didn't need to come from a full kitchen. It also allowed brewpubs to distribute their beer for sale off premises. They could also be located in economically distressed areas, whereas before they were strictly limited to registered historical locations.

To get the act passed, numerous compromises were made. The ABC Board took issue with removing the distinction between brewpubs and breweries. It did not want to combine the licenses into one that encompassed everything, so instead they left restrictions on the brewpubs in order to maintain a difference.

Resistance to the Brewery Modernization Act came again in the form of an Anheuser-Busch lobbyist. Working with its individual distributors, Anheuser-Busch tried to stop the passage of the Brewery Modernization Act. In 2011, Free the Hops leadership called for a boycott of the Anheuser-Busch wholesaler, as well as the distributors, which included Birmingham Budweiser and all of its products. Some of the beer that was being boycotted was from local breweries that would have benefited from the bill. This was a controversial move for Free the Hops and one that founder Danner Kline did not agree with. At the time, Danner was on the board of directors with Free the Hops, but he also worked for Birmingham Budweiser, so the other Free the Hops members cut him out of the decision, citing a conflict of interest. "No matter what might have happened, the boycott burned some bridges without benefiting Free the Hops," said Danner. "The bill would have passed without the boycott, which in fact only made things more difficult."

Despite the controversy of the boycott, a compromise was finally reached, and both Anheuser-Busch and Free the Hops were able to move forward with the common goal of increasing the availability and selection of beer in Alabama.

Free the Hops' third objective was to pass the Gourmet Bottle Bill, which increased the allowed bottle and can size to 25.4 ounces (750 milliliters). When the bill finally passed, Alabama was the only state in the country that banned beer container sizes over 16 ounces. Passing this bill increased the availability of more exclusive beers that were in 22-ounce bottles known as bombers.

The bill passed in May 2012 with little controversy. It seemed that Free the Hops had finally educated the public and legislators on what it was trying to accomplish and what a craft beer industry could mean to the state. In the beginning, craft beer brewers were compared to the bootleggers and

moonshiners of yesteryear, but now they were viewed as valuable members of the community who contributed to making Alabama a better state.

Free the Hops board member and former president Stuart Carter expressed this sentiment in an interview with the news organization AL.com: "As with all of our bills, this is an economic development issue. This is not about the alcohol, this is about the economic opportunities and the jobs being created."

Although Alabama was changing its commercial brewing laws, Right to Brew was still fighting for the right to home brew. The group's members had walked the statehouse floors until they were kicked out; they handed out flyers and compiled comprehensive pamphlets for legislators to explain why they wanted to home brew. Progress seemed to have stalled until Representative C. Mac McCutcheon took on the cause for Right to Brew. "Mac McCutcheon was awesome," said Scott Oberman. "He knew right away that we weren't a bunch of dirt bags mixing gin in the bathtub." This had not always been the case; during a 2011 legislative session, several politicians compared the home brewers to "winos," "bootleggers" and "moonshiners," not understanding that average home brewers did it

A growler being filled at Old Black Bear Brewery. Prior to 2016, it was illegal for breweries to sell beer to go. *Photo by Sarah Bélanger.*

because they enjoyed the hobby and not because they wanted a cheap and fast way to get drunk. Finally, on May 9, 2013, their effort paid off, and home brewing was legalized.

Free the Hops had accomplished its main objectives, but there were still laws that needed to be modernized, so it kept up the fight.

In 2015, Alabama remained the only state to prohibit customers from buying beer to-go from the brewery or brewpub. The Alabama Brewers Guild proposed the Brewery Job Bill in part to eliminate this restriction and help Alabama breweries be more competitive on a national level, thus creating new jobs and increasing tourism in the state. Free the Hops reached out to its membership and asked many to call their senators. The "growler" bill was the result of their

effort and was signed into law on June 1, 2016. This bill also removed the requirement that brewpubs be located in historic buildings or economically distressed areas or in counties that were wet prior to federal Prohibition. But as usual, some concessions had to be made, such as restricting to-go purchases to 288 ounces, an amount equivalent to a case of beer.

However, the struggle was not over, and in August 2016, the ABC Board proposed a change to how breweries kept track of beer sales. The proposal would require all breweries and brewpubs to keep a record of a customer's name, address, telephone number and date of birth for beer to-go purchases. This proposed law was supposed to prevent customers from purchasing more than the allotted 288 ounces of beer to-go, but both brewers and consumers viewed it as an invasion of privacy.

Free the Hops writer Nick Hudson made the point that "as nonsensical as it might seem, this rule would essentially empower the ABC Board to come to an individual's house to confirm his or her purchase of a six-pack of beer. It represents an unprecedented, unnecessary and overreaching invasion of privacy. It is something that unfairly targets beer consumers but also, frankly, has frightening implications for everyone."

Free the Hops rallied its membership and asked that citizens reach out to the ABC Board and complain about the proposed legislation. By September 2016, the ABC Board had decided to drop the requirement.

Being a consumer interest–driven organization, Free the Hops had focused its legislative efforts on issues that directly affect the consumer. By the end of 2016, those customer-focused legislative goals had been met and, in doing so, created a new craft beer industry in Alabama. Current Free the Hops president Carie Partain noted after Free the Hops legal objectives were met, it was the craft beer industry itself, rather than the consumer, that had the most vested interest to enact more changes. Thereafter, Alabama Brewers Guild took over the legislative mantle. Free the Hops continues its mission of promoting beer culture through education, while the Alabama Brewers Guild continues its promotion through brewer- and beer-friendly legislation.

Through the efforts of members of Free the Hops, Right to Brew and Alabama Brewers Guild, the landscape of the beer industry in the state has completely changed. Where once was a barren wasteland is now a growing and flourishing industry that is creating quality craft beer. The brewery owners strive to improve their communities, expand economic opportunities and create award-winning beer that would make any state proud.

HUNTSVILLE BREWERIES

OLDE TOWNE BREWING COMPANY

In 2004, Olde Towne Brewing Company became the first microbrewery in North Alabama since before state prohibition ended in 1915. Although the 1992 Brewpub Act had spawned several brewing businesses throughout the 1990s, North Alabama did not produce any local beer. That is, until Don Alan Hankins and Dr. Howard Miller became craft beer pioneers and opened Huntsville's first brewery in decades.

Don Alan had learned home brewing while he was a college student at the University of Alabama (UA). UA is also where he learned to appreciate more expensive beers. "I'm not saying that I never went to a 'penny beer' night, but I was usually more interested in any craft beer and imports." After college, Don Alan was able to turn his hobby into a career opening breweries across the South by working for City Breweries Investment Corporation. Don Alan opened brewpubs from the ground up in Mobile, Birmingham, Lexington and Baton Rouge, and it gave him valuable experience with staffing, construction and working with local municipalities. Don Alan also traveled to London and got his Master Brewer degree. All of these experiences would help when he opened Olde Towne Brewing Company.

Don Alan left the craft beer industry and took a job selling medical equipment. It was through this job that he met orthopedic surgeon Dr. Howard Miller, who was also interested in opening a brewery. The last

known brewery in North Alabama had been the Struvee Brewery, which shut down more than one hundred years earlier in 1876. The two brewing entrepreneurs were not sure how their brewery would do since there was little precedence, but they were optimistic. "The craft beer scene in Huntsville was pretty stagnant in 2004, so I think Huntsvillians were ready for a change," said Don Alan.

Don Alan decided to open a brewery as opposed to a brewpub. Although he would have liked to serve beer on site, he did not want to be restricted to a building in the National Register of Historic Places. He also did not want to run an eighty-seat restaurant, which would have required numerous employees and a massive cost. Because of this, Olde Towne opened as a distributing-only brewery. It opened in historical downtown Huntsville on Holmes Avenue.

In 2004, Alabama still had extremely restrictive laws, so the brewery faced numerous obstacles. "The beer laws did not change until 2009, so until then, I was bound by restrictive ABV laws," said Don Alan. "We had to be inventive to brew full-flavored beers under the legal limit." Despite the limitations, Olde Towne released its first beer at Humphrey's Bar and Grill in August 2004. Don Alan had been right: Huntsville was ready for a brewery. The brewery grew in popularity, and soon Olde Towne's beer could be found all over the state. It bottled four flagship beers—an amber, a pale ale, a hefeweizen and a pilsner—as well as several seasonal brews.

The brewery was doing well, but an early morning fire destroyed the building on July 5, 2007. "Sitting on a sidewalk and watching everything burn that you had worked so hard for was truly a heartbreaking and humbling experience," said Don Alan. "Luckily, I had a business partner that believed in what we were doing, so plans for reconstruction didn't take long."

They moved the brewery to a new location on Leeman Ferry Road and reopened in August 2008. In May 2009, Alabama passed the Gourmet Beer Bill, which meant beer could have more than 6 percent ABV. This same year, Don Alan left the brewery, but Olde Towne Brewing continued for another two years after his departure.

The brewery finally closed its doors in July 2011, just as the larger craft beer movement was gaining momentum in Alabama. A farewell party was thrown at The Nook, and although there were hopes that the brewery would reopen, it never did. Olde Towne had always been happy to help and support fellow breweries, so it contacted Straight to Ale to see if the owners were interested in taking over the brewery location. They jumped at the opportunity, and Straight to Ale relocated to the larger location.

Olde Towne was the first microbrewery to wet the whistle of Huntsville's thirsty beer lovers. Although the brewery closed just as the local beer market started to expand, it had left its mark on the city as being the first modern brewery in North Alabama.

Mad Malts Brewing

Question: What do you get when you mix a couple of NASA engineers, a plumber and a passion to brew?

Answer: Darn good beer.

Although Chris Bramon and Jeff Peck both worked as engineers in Huntsville for NASA, the first time they ever met was at Straight to Ale. Chris was an owner and brewer there, and Jeff was trying to start his own brewery. Jeff had never brewed on a large scale, so he came to Straight to Ale to have Chris show him the ropes and practice on the large equipment. Things did not go smoothly.

"Jeff was brewing with me, which was a comedy of errors that day," said Chris. "Jeff didn't know the equipment, and I assumed he did, so he ended up getting wet, a lot. Sometimes with very hot water." Despite the disastrous experience, both men thoroughly enjoyed brewing together.

Chris was a founding member of Straight to Ale, but as the brewery grew, it started to go in a different direction than he wanted, so he sold his quarter share back to the partners. "I went about six months after selling my share, and I knew I had to do another brewery," he said. "It gets in your blood."

He began wondering whom he wanted to partner with to start his new brewery and remembered how fun it was to brew with Jeff. One evening, the men ran into each other at the craft beer bar The Nook. Chris asked Jeff if he would be interested in partnering and starting a new brewery, and Jeff jumped at the opportunity. Jeff also invited his longtime friend and plumber Tracy Mullians to join the pair.

The engineering skills of Chris and Jeff would come in handy for getting the brewery up and running. They built their own glycol cooling system and cold box for a fraction of the price of a premade one. Tracy owns a plumbing business, so he handled all of the plumbing installations. Their combined skills helped them keep costs down. "All three of us are cheap at

In addition to numerous packaged beers, Liquor Express has more than one hundred beers on tap. *Photo by Sarah Bélanger.*

The bottling line at Back Forty Beer Company in Gadsden, Alabama. *Photo by Sarah Bélanger.*

The beer garden at the U.S. Space and Rocket Center in Huntsville, Alabama. Every Thursday, the beer garden offers authentic German food and local beers while raising money for different charities. *Photo by Sarah Bélanger.*

A flight at Goat Island Brewing in Cullman, Alabama. *Photo by Sarah Bélanger.*

The canning line in Old Black Bear Brewing's brewhouse in Madison, Alabama. *Photo by Sarah Bélanger.*

A flight at Rocket Republic Brewing Company. *Photo by Sarah Bélanger.*

Above: The band Round 2 at the 2016 Cullman Oktoberfest, performing a song they wrote about Goat Island Brewing. *Photo by Sarah Bélanger.*

Left: A pint at Singin' River Brewing. *Photo by Sarah Bélanger.*

Left: A beer at Yellowhammer Brewing at Campus 805. *Photo by Sarah Bélanger.*

Below: Grains used in Back Forty Beer Company's beer. *Photo by Sarah Bélanger.*

Ms. Baconette at Straight to Ale Brewing's Annual Rocket City Bacon and Beer Bash at its Leeman Ferry Road location. *Photo by Sarah Bélanger.*

Reverend John Richter, the burgermeister of the 2016 Cullman Oktoberfest. He is the great-great-grandson of saloon owner and beer maker Wilhelm Friedrich Richter. Goat Island Brewing used a 150-year-old recipe written by Wilhelm to develop its Richter's Pils. *Photo by Sarah Bélanger.*

Left: Signage from the first Albertville Brewfest, founded in 2015. *Photo by Sarah Bélanger.*

Below: Yellowhammer hosts a monthly book club called the Book Report. Members drink beer and discuss various books. *Photo by Sarah Bélanger.*

Above: Old Town Beer Exchange is one of Huntsville's premier bottle shops and taprooms. Much of the interior is refurbished from local materials. *Photo by Sarah Bélanger.*

Left: Straight to Ale's most popular beer, Monkeynaut. It is named after the brave monkey, Miss Baker, that traveled to space and back in 1959. *Photo by Sarah Bélanger.*

Right: The fish-shaped flight paddle from Main Channel Brewing in Guntersville. *Photo by Sarah Bélanger.*

Below: The taproom at Goat Island Brewing. *Photo by Sarah Bélanger.*

For almost thirty years, Cullman hosted the world's largest dry Oktoberfest. In 2011, it finally went wet. *Photo by Sarah Bélanger.*

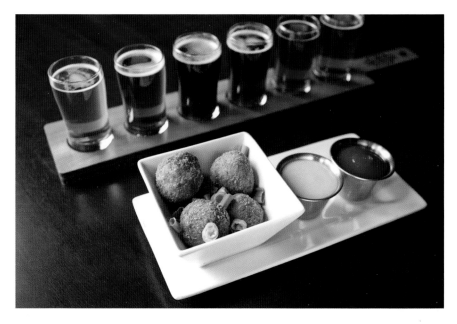

Beer and food pairing is very important to Below the Radar Brewpub. *Photo by Sarah Bélanger.*

Left: The blue pants flight paddle at Blue Pants Brewing. *Photo by Sarah Bélanger.*

Below: Southern Growler ceramists Aaron Keen and Clay Krieg. *Photo by Sarah Bélanger.*

Straight to Ale Brewing volunteers at the 2016 Rocket City Brewfest. *Photo by Sarah Bélanger.*

A pint at Mad Malts Brewing in Huntsville, Alabama. *Photo by Sarah Bélanger.*

Jason Sledd's 1972 Volkswagen Bus, after which he named Green Bus Brewing. *Photo by Sarah Bélanger.*

Salty Nut Brewery showing its support of local breweries. *Photo by Sarah Bélanger.*

A frothy pint at Rocket Republic Brewing Company in Madison, Alabama. *Photo by Sarah Bélanger.*

Beer taps at Singin' River Brewing in Florence, Alabama. *Photo by Sarah Bélanger.*

Right: Salty Nut's notorious beer Unimpeachable, which was brewed after Alabama's governor had an alleged affair with a member of his staff and faced impeachment. *Photo by Sarah Bélanger.*

Below: A local band performing at Mad Malts Brewing in Huntsville. *Photo by Sarah Bélanger.*

Above: The grinding system at Back Forty Beer Company. *Photo by Sarah Bélanger.*

Left: Beer at the U.S. Space and Rocket Center's beer garden. *Photo by Sarah Bélanger.*

Jeff Peck, Chris Bramon and Tracy Mullians in their brewery, Mad Malts Brewing, formerly Brew Stooges. *Photo by Sarah Bélanger.*

heart," said Chris. "Plus we were on a shoestring budget because we were self-funded and continue to be."

Although Chris and Jeff were more experienced at brewing, Tracy became quite good over time. The first three beers they brewed were an English-style bitter, a porter and a rye beer. To their surprise, the porter was the most popular. They tweaked the recipe to create a vanilla porter, which was an instant hit. It continues to be their most popular beer; they sell three times more of the vanilla porter than all of their other brews combined.

The brewers do not adhere to a particular style and like to experiment with lots of different recipes. In addition to the malty porters, bitter IPAs and refreshing sessions, they produce several sour beers, which are notoriously difficult to brew. Their Alabama Gose sour took a full two years to develop. But the brewers do not mind; they love the process of brewing. "I just brew what I like, and I like a lot of stuff," said Chris.

Early on, the trio wanted to come up with a fun name that epitomized the spirit of their brewery, and that name would come from another brewing mishap. The brewery had just received a new brewing system, and Jeff and Tracy decided to brew a batch of beer with it. "Everything that we could do wrong we did do wrong," said Jeff. The two made countless mistakes, and

soon they could only laugh at what a disaster their brewing attempt was. "After a while, I just looked at Tracy and said, 'We're a couple of stooges.'" They loved the name and decided to name the brewery Brew Stooges. Chris contacted the company that retains the rights of the Three Stooges, C3 Entertainment, to make sure the brewery could use the name Brew Stooges. C3 approved the name, but two years later, the entertainment company had an issue with the logo, which depicted the three brewers standing around a pot with hairstyles like the Three Stooges characters. After several months of negotiations, it became clear to Chris that C3 wanted too much control over their brewery's identity, so they opted to rebrand and restructure the business.

The brewers wanted to keep their zany style, so when Jeff suggested Mad Malts, they knew it was perfect for them. "Jeff always had a thing about mad scientists because both of us are NASA scientists," said Chris. The name is also a nod to the maltier beer styles that they brew.

They also completely changed their business plan and marketing strategy. Despite Brew Stooges being available throughout all of Alabama, Mad Malts started from scratch and initially was only available in Huntsville. They have expanded back out to North Alabama and are

The brewing tanks at Mad Malts Brewing. *Photo by Sarah Bélanger.*

slowly entering the rest of the state. This is working for them, and they are now selling more beer than ever, despite the shorter reach.

Keeping the brewery small also allows them the flexibility to do what they want, host events and have fun. "We are very laid-back," said Chris. "It's just like drinking beer in your garage, and you'll always be welcome and you'll always have a great time with us." There is usually something going on in Mad Malts. On Saturdays, they have a band. "We pull guys out of their garage and put them in our brewery," said Chris. Despite being novices, the bands have talent, and often Mad Malts is where these musicians get their start. They also give numerous food trucks a venue. One popular food truck, Dr. Barbeque, got its start at Mad Malts after the brewers met the owner at Rocket City Brewfest. They loved his barbecue, and he loved their beer, so it was a match made in heaven. Mad Malts is also part of both the beer trolley tour called "Beer Hop" and "Bikes and Brews," a group of bikers that meets once a month to bicycle across Huntsville to drink beer. Mad Malts also hosts painting classes and art exhibits.

As Mad Malts grows, the brewers will continue to experiment and push the envelope, but their main goal is to always to create good beer for their thirsty fans.

BELOW THE RADAR

After the Gourmet Beer Bill passed in 2009, breweries popped up across North Alabama. By 2012, Huntsville had several of them, including Straight to Ale, Yellowhammer and Blue Pants, with Salty Nut well on its way. But the city did not have a single brewpub.

There are several differences between brewpubs and breweries, but the main distinction is that brewpubs can serve beer from other breweries, while breweries can only serve beer they manufactured themselves. Alabama brewpubs were created in 1992, but legislators worried that they would have a negative impact on communities, so they imposed numerous restrictions. These restrictions impeded the success of many brewpubs.

When the beer laws started changing in 2009, many restrictions went away. Even so, no brewpub had existed in North Alabama since 1915. Friends Martin Cousins and Steve Below wanted to change that. They paired up with aerospace engineer and entrepreneur Dan Bodeker to open the first modern brewpub in North Alabama.

The founders named the brewpub Below the Radar because many of them were home brewers at a time when it was not strictly legal in Alabama—they had to do it "under the radar." They altered the name to "Below the Radar" after founder Steve Below.

When Below the Radar was first getting started in 2012, both the Gourmet Beer Bill and Brewery Modernization Act had been passed, which meant the ABV in beer had been raised to 13.9 percent and breweries could have taprooms in which to serve their beer. It also meant that although brewpubs still needed to serve food, they were no longer required to have an eighty-seat restaurant. The one restriction that remained was that brewpubs had to be located in a nationally registered historic building or an economically distressed area.

Below the Radar built its brewpub in the Times Building, one of the city's oldest structures. It was located not far from where Olde Towne Brewing Company had stood before a fire destroyed it.

One of the issues with being in a historic building was that numerous renovations had to happen before the brewpub could be functional. Knowing that it would take a lot of time before Below the Radar would be able to brew, the owners decided to contract-brew at Yellowhammer.

Below the Radar Brewpub located in the historical Times Building. It was North Alabama's first brewpub since before 1915. *Photo by Sarah Bélanger.*

Pints of beer at Below the Radar Brewpub in Huntsville. *Photo by Sarah Bélanger.*

In the early days of contract brewing, home brewer John Tipton developed many of Below the Radar's beer recipes. John has decades of brewing experience and is a home brewing icon in Huntsville. According to Martin Cousins, many of the great beers that Huntsville is producing can be traced back to John. His home brew recipes were scaled up to commercial-sized batches by Yellowhammer's brew master, Keith Yager.

Despite the success with contract brewing, Below the Rader always planned on opening its own on-premises brewhouse, but because of several unexpected problems, it took three years before this happened.

One big obstacle that delayed getting the brewhouse off the ground was the legal requirement of having a concrete dam to catch beer if a tank bursts. This required twenty tons of concrete, and that weight, combined with the weight of tanks filled with beer, was too much for the nearly ninety-year-old building. To create a structurally sound area, sixteen braces had to be placed in the lower floor, which housed Drake State Technical College. Because there were students using the building, Below the Radar had to wait until the school's winter break to do construction; this delayed the process by six months. Despite the many setbacks, Below the Radar finally got the brewing side up and running in May 2015.

Shortly after setting up the on-premises brewhouse, the new equipment got a wild yeast infection; the infection spread throughout the system. To help fight the infection, Below the Radar called Hudson Alpha, a local biotechnology research center, to help clear up the system. As Hudson Alpha worked to fix the brewing equipment, it was mentioned that a brewer at Back Forty, Eric Tollison, was looking to move to Huntsville, and as luck would have it, Below the Radar was looking for a brewer. While the infection was unfortunate, it did lead to Eric Tollison becoming the new head brewer.

Below the Radar is still the only brewpub in North Alabama. Dan is happy that being a brewpub allows him to support the other breweries. "I'm the only one in town that can sell the other guys' beers," said Dan. "Thirty percent of our customers are from out of town, and they want to drink local beers from different breweries," said Dan. "We tell them about the Downtown Beer Trail, so they can visit all the other breweries as well." Even so, 50 percent of its taproom sales are Below the Radar's in-house brews, which is partially due to the brewpub's beer being tailored to pair well with the restaurant's dishes. From the very beginning, Below the Radar's food was just as important as the beer. In fact, the guys create their beer to complement the food and food to complement the beer. Many of the dishes are even cooked with the beer.

Over the years, the brewery has changed and expanded. In addition to the brewhouse, the owners remodeled and increased the kitchen capacity and added seating both inside and out. "Everything we originally started with in the brewery has been sold off or disposed of, and everything is brand new."

The brewery is also hoping to add an additional off-site location to keep up with demand. The new location would include a sixty-barrel system, which is significantly larger than the seven-barrel system currently on site.

Below the Radar supports numerous causes throughout the community. "We're big supporters of the Museum of Art events, as well as several large charity events held at the Huntsville Botanical Garden," said Dan. One of his favorite charity events is ProBono Brews, a fundraiser for the Madison County Volunteer Lawyers Program, which provides low-income citizens equal access to legal services. "All of the local breweries have done a good job supporting events and charities," said Dan.

Although it has been a long road, Below the Radar's patrons can finally enjoy a beer that was brewed in North Alabama's first brewpub.

Green Bus Brewing

You would be hard pressed to get brewer Jason Sledd to say which he loved more, home brewing or Volkswagens. He loves both, so when he started his brewery, he made sure that his 1972 Volkswagen bus was a central part of the brand.

Jason first got into brewing around 2011, four and a half years before he started his commercial brewery. He bought most of his equipment and recipe kit from the craft beer store Alabrew in Pelham, brewed a pilsner and was hooked almost immediately. After brewing on his own for a year, he joined Huntsville's home brewing club. "I started hanging out with the Rocket City Brewers, and it was through them that my eyes were open to the vast expanse of what beer is and what it can be," said Jason.

His three years of being a member of Rocket City Brewers allowed Jason to hone his brewing skills and make great professional contacts. He connected with the brewers of Straight to Ale and started making his home recipes on their smaller brewing equipment. The owners of Straight to Ale let Jason do test batches on their thirty-gallon system and told him that if he did a good batch, they would sell it in their taproom. He brewed a watermelon wheat beer and a lemon-lime wheat beer, and both were instant hits. Then Straight to Ale hosted a home brewers' competition, and Jason entered his watermelon wheat. It was hugely popular, so the owners decided to brew Jason's recipe in larger commercial batches. It became one of Straight to Ale's seasonal brews. It was then that Jason started considering opening his own brewery. But the other members of Rocket City Brewers who already owned breweries cautioned him that it would diminish his love of home brewing. They told him that his hobby would turn into a big business, and instead of brewing what he wanted he would simply be running a production facility. Jason acquiesced. He continued home brewing and learned what he could from the commercial brewers.

The Alabama Brewers Guild considered hosting a statewide home brewing competition. Jason paired up with several other brewers, and he dubbed his group Green Bus Brewing after his 1972 green Volkswagen Bus. Jason had been an avid Volkswagen collector for longer than he had been a brewer, and the name reflected both of his loves. The competition never took place, but it gave Jason his brewery's name and brand.

Jason still could not decide if he wanted to open Green Bus Brewing, so he asked Dan Perry, founder and co-owner of Straight to Ale, how he would recommend doing a brewery so he could maintain his love of

Crowds surrounding Green Bus Brewing during its grand opening. *Photo by Sarah Bélanger.*

A pint of beer at Green Bus Brewing. *Photo by Sarah Bélanger.*

brewing. "Dan told me I needed just a small brewery with a taproom and not to worry about distribution." He told Jason to keep it small so he could just relax and brew the types of beer he wanted to. Jason took this advice to heart and set out to open a nanobrewery—a tiny brewery kept intentionally small and that only brews enough beer for on-premise sales. Jason figured he could brew small batches, just enough to serve in the taproom and at occasional events.

Jason had several potential business partners, but in the end, he decided to build the brewery with fellow Rocket City Brewers member Carey Huff and his wife, Haley Huff.

They found a perfectly sized building in downtown Huntsville, but it was in rough shape. The 150-year-old structure had history and charm; it had even been a saloon in the late 1880s. The bones were good, but it had been abandoned for many years, and it showed. When the building closed, it was a law firm, so the interior was made up of sectioned-off offices with drop ceilings and 1980s décor. There was also a six-inch sag in the second floor. But Jason could see the potential, and the owner was happy to work with him. She wanted somebody to come in and renovate the building because she did not want to do it herself. So, she made a deal with the brewery owners, giving them a long-term, low-rate lease in exchange for them overhauling the interior. The renovations took thirteen months. They had to completely gut the building and remove all the drop ceilings, stairs and even some floors. "For a while there, you'd open the front door and you'd have to take a ladder into the basement," said Jason. Carey was responsible for most of the renovation process and did a lot of the labor himself.

They installed a small brewing system that was only capable of brewing forty-five gallons at a time. This allowed them to have several flagship beers, including their Dominant Red, Tiramisu Milk Stout, Hop Bus IPA and Bus Ride Pale, in addition to numerous seasonal and one-off brews. Dominant Red, an Irish red ale, was the first beer released and was popular right away.

Green Bus Brewing's beer styles strike a healthy balance between traditional and experimental. "We're in downtown Huntsville, where there is a lot of history here, but there is also a lot of revitalization and new stuff here…that's how I pictured Green Bus," said Jason. "You can come in here and find some good classic-style beers that people have been drinking for hundreds of years, and you can also come in here and find the Earl Grey Mild, which is an English mild ale with Earl Grey tea added."

Green Bus's grand opening was October 1, 2016, and hordes of thirsty beer lovers were in attendance. Many were getting their pictures taken with Jason's green bus, parked out front. All the brewery owners were excited to finally have the brewery up and running and the beer flowing, and Jason was especially happy that he was able to create a business that combined his two loves.

HUNTSVILLE'S BREWERS' ROW

Straight to Ale Brewing

Huntsville native Dan Perry was in the U.S. Army stationed in Georgia the first time he home brewed in 1987. By his own admission, the beer he brewed was awful, but he enjoyed the hobby so much he stuck with it. After he left the army, Dan moved back to Huntsville to work with an engineering company.

In 1990, he joined a local home brewing group called the Madison Sobriety Club. There were only eight or nine members, but they were passionate about their craft. "There were some amazing home brewers in that club," said Dan. "They took me under their wing and told me, 'Your beer sucks…but here's why.' They gave me a hard time, but they taught me what I was doing wrong and taught me how to do it right. My beer quality went from something I was barely able to drink to something I was proud of."

The brewing group was quite skilled, and although it was illegal to home brew in Alabama, the group's members still won numerous southeastern brewing competitions. The group grew and in the early 2000s officially changed its name to the Rocket City Brewers. Dan's brewing skills had vastly improved from his army days, and he started winning numerous home brewing competitions. As his confidence as a brewer grew, he became more passionate about his hobby.

Dan had a twelve- by twenty-four-foot shed in his backyard where he would home brew with his friends. He came up with the name for his backyard brewery while attending the Southern Brewers Festival in Chattanooga, which features numerous southeastern breweries, as well as live music. While listening to southern rock band Drivin' N' Cryin' sing their hit song "Straight to Hell," it struck Dan that "Straight to Ale" would be a great name for his home brew shed. "We put a sign on it, and I made some T-shirts just to be silly." His friend and home brewer Rich Partain designed the iconic devil tail logo. Little did any of them know that the Straight to Ale home brew shed would eventually grow into a full-fledged brewery, selling beer throughout seven states. But at that time, in the early 2000s, Alabama's brewing laws were very restrictive.

In 2006, Dan read an article about Danner Kline's Free the Hops movement and immediately contacted him. Danner traveled to Huntsville, and by the time he was headed back to Birmingham, plans were underway to create a Huntsville chapter of Free the Hops. Dan and the home brewing group worked hard to change the laws that were holding back the state's craft beer industry. Dan had dreamed of starting a brewery that served big flavored beers, and raising the 6 percent ABV cap would allow him to brew those beers.

Dan started making plans to open a brewery if any of the beer laws changed. He said, "One day there were four of us in the driveway just brewing and drinking, we agreed that if the laws changed, we were going to start a brewery." The four men were Dan Perry, Rick Tarvin, Chris Bramon and Brant Warren. They shook hands and waited for the impossible—for Alabama, a state with some of the strictest liquor laws in the country, to change its beer laws. In May 2009, Dan was shocked when Governor Riley actually signed the bill allowing beer to have higher alcohol content. "My wife said, 'Put up or shut up, start a brewery or stop talking about it,'" said Dan. So he did just that. Rick Tarvin and Chris Bramon were ready, but Brant Warren decided to stick to home brewing, so the other founders partnered with Colin Austin and Bruce and Jo Weddendorf. In 2009, they opened Straight to Ale in a five-hundred-square-foot section of Lincoln Mill. "It had no windows and looked like a bombed-out building, but it worked," said Dan.

Although a step up from Dan's brewing shed, Straight to Ale was still small, with a three-barrel brewing system and no taproom, which was not legal yet anyways. Straight to Ale introduced its first beer, Monkeynaut IPA, to the public in May 2010 at The Nook. From there, things took off. "Our

whole mission was to have a cool place to hang out with our friends and drink beer," Dan said. But they had not anticipated how ready Huntsville was for strong-flavored stouts and IPAs, and within a few weeks, they could not keep up with demand.

Within a year, they had to move to a larger location. When Olde Towne Brewing Company closed, the owners contacted Dan about moving into their ten-thousand-square-foot building on Leeman Ferry Road in Huntsville. The building was far too big for what Straight to Ale currently needed, but Dan recognized that over time they would grow into it. "I thought we'd never need anything bigger than this," he said. Straight to Ale would outgrow the building within five years. Although they wanted to keep their brewery on Leeman Ferry Road, Straight to Ale needed extra space for brewing and entertaining.

As they looked for an additional location, they found that the City of Huntsville was trying to revitalize the area of the former Stone Middle School. The school had closed in 2009 due to low enrollment and had remained empty for several years. It was proposed that Straight to Ale partner with several other breweries and businesses to create an entertainment area called Campus 805. Although there would be a massive amount of renovations to be done, Straight to Ale signed on to be one of the breweries on the campus. The brewery would be housed in the gymnasium and would give Straight to

Straight to Ale Brewing's second location at the Campus 805. *Photo by Sarah Bélanger.*

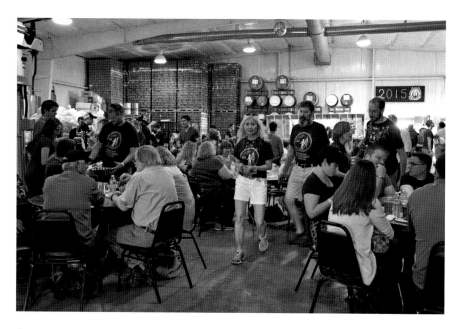

Crowds enjoying the bacon cooking competition during Rocket City Bacon and Beer Bash at Straight to Ale on Leeman Ferry Road. *Photo by Sarah Bélanger.*

Ale ample room for expansion when the time came. To keep the character of the school in place, Dan refurbished as much as he could and kept fixtures intact. Dan's brother used the gymnasium floor to build the brewery's tables. The boys' and girls' bathrooms kept their school-like appearance, and the basketball hoops remain on the walls in the brewhouse.

The new location has an attached restaurant, Ale's Kitchen, which is owned by Dave Stanely. Dave has the distinction of owning Huntsville's first food truck, No Breaks Bistro. His food truck was extremely popular at the Leeman Ferry Road Straight to Ale, but due to restrictive food truck laws in Huntsville, he stopped his service. When Campus 805 was opening, Straight to Ale's owners asked Dave to open a restaurant in the brewery.

Another big change for Straight to Ale is its added distillery, called Shelta Cavern Spirits. The distillery makes numerous liquors, including whiskey, rum and vodka. In addition to selling bottles of their liquor, Straight to Ale serves cocktails made with spirits in a secret Prohibition-styled speakeasy hidden behind a secret door within the brewery.

The brewery has various entertainment areas, allowing it to host many events. Event and public relations director Leslie Bruton said they have gone from hosting four or five events a week to hosting seven to fifteen a week. It

is also important to Straight to Ale to support the community. "We're really big advocates for ways that craft beer can help the community," said Leslie. "In general, in Alabama, beer has had a negative stigma, so we have worked really hard to show how beer doesn't have to be all about getting drunk. It is about a refined palate, specific tastes and supporting a community."

Straight to Ale hosts numerous charitable events throughout the year, but some of its favorites include the Bacon and Beer Bash, which benefits the organization Still Serving Veterans. The brewery's list of charities it supports is vast, and it tries to accommodate as many groups as it can. "We work to be impartial and non-partisan," said Leslie. "We want to be the place where you never know what's going to happen."

The brewery grew faster than any of the founders expected and has expanded across seven states, but they still remember their roots by adding local touches to their beer and marketing. This might be by celebrating Huntsville's space program and naming a beer after the monkeys that traveled to space, 6 Alberts, or by using locally roasted coffee in their stouts. "We try to tie in memories of Huntsville and what Huntsville is about in pretty much everything we do," said Dan. "It's a little harder now that we cover more states, but still, we are from Huntsville; we're proud of it, and we want to share that with everybody."

Yellowhammer Brewing

As the brewing laws began to change in Alabama, new brewpubs and breweries opened across the state. While many brewery owners were thrilled that the Beer Modernization Act allowed them to brew higher-gravity beer, realtor Ethan Couch was also excited about the City of Huntsville changing zoning laws. The new zoning meant breweries could be located in much less expensive areas and, therefore, be more financially viable. "I came at it from a real estate perspective," said Ethan. "I noticed that when Olde Towne Brewing moved after the original building burned down, the new zoning laws meant they were able to move to Leeman Ferry Road," said Ethan. He realized that the new regulations brought the cost of renting a facility from twenty dollars per square foot to four, making it more affordable to start a small brewery.

In 2009, he talked to two friends, Don Milligan and Challen Stephens, about opening a brewery. Challen worked for the *Huntsville Times* with

Keith Yager, who was a graphic designer by day and expert home brewer by night. Keith was from Pennsylvania, and when he moved to Alabama, he was sorely disappointed in the lack of beer selection in the state. He started home brewing so that he could drink the beers he was missing out on. The four men met and, before long, were making concrete plans to create Yellowhammer Brewing.

Ethan found an affordable location with the needed amenities for a brewery: high ceilings, an open floor plan and plenty of storage space. In the beginning, Yellowhammer was austere, located in a beige metal building with limited signage and no taproom. Although Yellowhammer was small, the owners were striving to brew the highest-quality beer they could.

On October 16, 2010, they released their first two beers to the public, an IPA and a Belgian-styled white ale. Both beers were popular, but the Belgian white quickly garnered a following and became a signature beer for Yellowhammer. Over the past six years, the Belgian white has remained the brewery's most popular beer.

In June 2011, the Brewery Modernization Act allowed Yellowhammer to add a taproom in the brewery. This made it possible for brewers Keith and Don to experiment with smaller batches of specialty beer. "The taproom gives us an avenue to place a lot of different products in the market," said Ethan. If a small batch did well in the taproom, the brewery would make the recipe in larger batches for distribution.

The patio of Yellowhammer Brewing at Campus 805 in Huntsville. *Photo by Sarah Bélanger.*

The brewers started experimenting with barrel-aged beers and different styles, as well as adding twists to familiar styles. "A brewer is like a cook in a kitchen—they have to add a little of this and a little of that and keep on experimenting until you find that magic combination," said Ethan. "Keith is really good at that. He is a beer chef, so to speak."

Over the years, Yellowhammer grew, and the brewery became more polished. The guys brought in a new partner, Bill Roark, in 2014. The brewery also added new brewing equipment and signage, expanded the taproom and created a beer garden. The beer garden was Ethan's pet project. It included a finished patio, numerous benches, ambient lighting and a stage for bands. But just as the brewery seemed done with its renovations, Yellowhammer got the opportunity to move.

The City of Huntsville had been busy revitalizing certain areas, and one place that needed some love was the former Stone Middle School. The school closed in 2009 due to low enrollment and had been sitting empty for five years until developer Randy Schrimsher purchased the thirteen-acre campus. Soon after this, Straight to Ale and Yellowhammer signed on to be a part of a new entertainment facility.

"We loved the old place and we put a lot of time and effort into that location, but then we got the opportunity to move to the 805 school campus," said Ethan. "We talked to Straight to Ale and the City of Huntsville, and it seemed like a great opportunity for not only us, but for the city as well. It also allowed craft beer enthusiasts to come to a central destination to see what Huntsville has to offer in terms of beer."

Yellowhammer moved into its new location in December 2015, and Salty Nut Brewing took over the old location. The thirteen acres were dubbed the Campus 805, which also housed the Lone Goose Saloon and bottle shop Wish You Were Beer. The nickname for the area is "Brewers' Row" and aims to be a one-stop destination for visitors to experience several breweries and craft beer venues.

Yellowhammer's new location was built over the school's track field. Because they were building the new facilities from the ground up, the owners were able to customize the brewery to fit their needs and leave room for expansion. In addition to a bigger brewing area, Yellowhammer would have two large patios, a huge taproom and a custom bar. They also partnered with the owners of a popular pizza food truck. "Earth and Stone was our most popular food truck, so we asked them if they wanted to be in the brewery," said Ethan. Initially they said no but came around, and it has been a great partnership for both businesses. The addition of

Yellowhammer's volunteers at the 2016 Rocket City Brewfest in Huntsville. *Photo by Sarah Bélanger.*

artisan pizza and gourmet ice cream has helped the brewery maintain a family atmosphere.

"We work to be family friendly," said Ethan. "A lot of us have kids ourselves, so it makes sense for us to be family friendly. I personally think that exposing responsible drinking to children is a good way to teach them." There is a park that connects Yellowhammer to Straight to Ale, and it is a place for children to play Frisbee or kickball while their parents enjoy a pint on the adjacent patios.

The brewery also strives to use its resources to do good things in their community. "We do a lot with charities," Ethan said. "Some of my favorites are the Food Bank, which does a wonderful job of providing meals for people in need. What they can do with so little is really impressive." Yellowhammer also supports HEALS, which provides free dental and healthcare to underprivileged children.

The brewery continues to grow and expand at a rate that none of the founders fully expected. Although they do not know what is coming, the future looks bright. "We had no idea where this was going to go or where the craft beer movement was going to go," said Ethan. "I feel like we've just moved from our infancy to toddlerhood. We're just starting to take big steps. We want to still be here in twenty, thirty, fifty years. I'd love to see us be a staple for Huntsville and Alabama for a long time to come."

SALTY NUT BREWING

The first time Brent Cole brewed beer in his home, it did not go well. He had bought a beer kit online, but once it arrived it didn't have all the equipment he needed. He had to drive all over town to buy what was not included in the kit. "When I finally made the beer, it was terrible. My wife

was like, 'That smells horrible! You've got to get it out of the house!'" he said. The beer was undrinkable. Not one to give up, Brent bought a second, higher-quality kit. Although the results were better, they still were not great. But as the old adage goes, the third time was the charm. "The third attempt, I thought 'screw it' and used my own recipe, and it was great!" said Brent. That recipe ended up being HopNaughty, one of the brewery's most popular flagship beers. Going forward, Brent stuck to his own recipes and had much more success.

Brent is an aerospace engineer who specializes in 3D computer modeling. Brewing allows him to tap into his creative side while utilizing his engineering skills. "You still have to run the numbers, you still overthink everything, but brewing beer is a way to be creative and artistic in a different way." He joined the home brewing group Rocket City Brewers and, through the organization, got to know the brewers at Olde Towne Brewing Company and Straight to Ale. He volunteered at Olde Towne in order to have a better understanding of the commercial side of brewing.

Brent was sure that if Alabama's beer laws changed, he would start a brewery. His home brewing friend Mark Ivie was less sure. When the laws did change in 2009, Brent was ready to go. "I told Mark, 'I'm going to do this brewery thing,' and he said, 'You're crazy. Don't do this.' And I said, 'I'm doing it anyways' and just kept on filling out the paperwork," said Brent. Despite his protests, when the time came, Mark helped Brent start the brewery by putting money into the business and brewing. Early on, their friend Daniel Yants helped out as well. Daniel worked in the financial sector, so he worked as the brewery's accountant. The brewery later hired an official accountant, but Daniel stayed on and became the assistant brew master.

The brewery's name came from an unlikely place: a virtual rock band. On the weekends, Brent and several of his friends would get together to play the video game *Rock Band*. The game allows the players to name their virtual band, so the friends tried to dub themselves Salty Nut. But, alas, *Rock Band* deemed the name too vulgar, so they had to rock out as Salty Peanuts. When the time came to name the brewery, Mark suggested their original band name, and Salty Nut Brewing was born.

The brewery incorporated in 2011 but did not sell its first beer until 2013. This was in large part because commercial brewing was still in its infancy in Alabama, so there were not a lot of resources for new brewery owners. "No one really knew what to do and how to go about starting a brewery," said Brent. "The state didn't know what to tell you about how to do things. No one was on the same page."

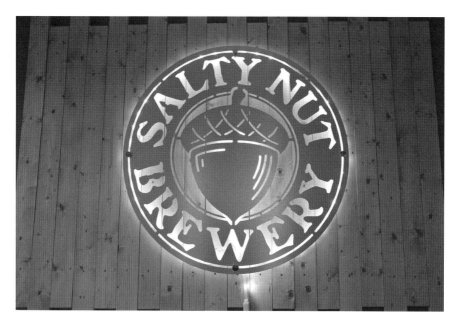

Salty Nut Brewery signage. Salty Nut is a part of Brewers' Row in Huntsville. *Photo by Sarah Bélanger.*

Salty Nut Brewery on Brewers' Row. *Photo by Sarah Bélanger.*

Existing breweries and organizations such as Free the Hops and Right to Brew were working hard to educate the Alabama population about craft beer, but it took time. "It was still so new, people didn't know there was more than Bud Light and Miller Lite out there," said Brent. When Salty Nut finally did start brewing in 2013, it was one of the smallest breweries in the state. This allowed the guys to develop their own unique style with a fun taproom, lots of quirky events such as adult coloring and great beers with bawdy names.

In July 2013, they released their first beer at The Nook, an Irish red ale named Imperial Mustache Red to celebrate their friend's epic mustache—which, by the way, won first place in the World Mustache Championship in Alaska. The next beer released was Hawt Blonde, a refreshing yet mildly spicy American blonde ale.

Perhaps their most notorious beer was a peach-flavored wheat ale named after Alabama's controversial governor Robert Bentley. In 2016, Governor Bentley became embroiled in a scandal after he had an alleged affair with one of his top aides. It was speculated that the governor would be impeached from office, so Salty Nut named its beer Unimpeachable Pale Ale after the incident. "If anyone's going to do it, we're going to do it," said Brent. "We don't hold back on anything." The creative agency Red Brick Strategies came up with a logo depicting the governor tightly squeezing a very provocative-looking peach. Salty Nut released the beer at the 2016 Rocket City Brewfest and ran out almost immediately. It was definitely the hit it was hoping for. In April 2017, Governor Bentley resigned from his post before he was impeached.

When the brewery first opened, it only brewed five gallons at a time. It had two taps and only a handful of seats in its tiny taproom. As luck would have it, when it got ready to expand, Yellowhammer Brewing was moving to a new location. Salty Nut was able to move into Yellowhammer's former building. It now would be able to brew seventy gallons at a time and had room to grow. The new location included a beautiful beer garden and ample seating. It is also in a prime location, just down the street from Straight to Ale and Yellowhammer's new locations and is near the Lonely Goose Saloon, as well as the craft beer emporium and home brew store Wish You Were Beer. This craft beer–heavy area has been dubbed "Brewers' Row." Brent was thrilled to be a part of this up-and-coming area.

Although Brent takes the business of brewing beer seriously, he hopes after its recent expansion Salty Nut remains a casual and fun place. "I want to be the most chill, relaxed place to have a good time and drink beer," said Brent. "We enjoy what we do here, and we want you, the customer, to enjoy it, too."

MADISON BREWERIES

Blue Pants Brewery

When Jason Spratley went to the University of Michigan, he was given the nickname "Pants." No one is sure why—just a college name that stuck. While at school, he met Allison and was struck by her pretty clear blue eyes, so he gave her the nickname "Blue." Eventually, "Pants" and "Blue" got married, and the couple moved to Jason's home state of Alabama.

Jason had picked up home brewing during college and was excited when Alabama's beer laws started to change. Although he was working as an aerospace engineer and Allison was a schoolteacher, they decided to start a small commercial brewery. They used their college nicknames, and a year after the Gourmet Beer Bill passed, Blue Pants Brewery was created. To say the brewery was small was an understatement; the four-hundred-square-foot portion of a building in Huntsville belonged to one of Jason's co-workers. All of the equipment was refurbished, and Jason and Allison used their own money and a small loan to finance the operation. At the time, it was the smallest brewery in the state, but the beer was an instant hit.

The brewery released its first beer, Knickerbocker Red, in October 2010 at the craft beer bar The Nook. Over the next eight months, Blue Pants continued to grow, and with the success they were having, Jason and Allison knew they needed a bigger facility and better equipment.

"After about a year in that small place, we realized that if we were going to continue to be successful, we couldn't keep brewing there," said Allison. "The equipment and small space was really limiting any growth and causing quality issues."

At the time they were searching for a new location, Straight to Ale and Yellowhammer were opening breweries in Huntsville, so the Spratleys set their sights on the city of Madison. "We live in Madison, I worked in Madison and Jason's family is in Madison, so moving the brewery to Madison was a no brainer," said Allison. "We also liked the idea of being Madison's first brewery *ever*."

But because Blue Pants was Madison's first brewery, getting the correct licensing was a bit of a challenge. "The city didn't know what to do with us," said Allison. "We were blazing this trail of creating a brewery" in a town that never had a commercial brewery. Although it was a struggle, the City of Madison was extremely helpful and worked with the Spratleys to make sure Blue Pants opened. "It was a learning experience for everyone," said Allison. The residents also embraced Blue Pants, and almost immediately the brewery was filled with regular customers. Many of their first customers were from software corporation Intergraph, and they continue to be regulars.

To say thank you to their most devoted customers, the Spratleys created the Blue Pants Mug Club. The inside perimeter of the new brewery was lined

The taproom of Blue Pants Brewery in Madison. *Photo by Sarah Bélanger.*

with 165 numbered silver mugs, each belonging to a Mug Club member. In addition to receiving invitations to exclusive events, members are served beer in their own special mug. The club is just for fun, but Allison said that a lot of the first Mug Club members have been there almost from day one.

The City of Madison was very welcoming to its first brewery, and in return, the Spratleys strive to be a valuable part of their community. They do this through numerous charity and community events. Every week, the brewery partners with different nonprofit organizations for a charity evening called We Care Wednesday. In addition to having a venue to promote themselves, the nonprofit group also receives a portion of the beer proceeds for its charity.

The larger new location also allowed the brewery to host events such as its annual stout festival Pinstripe Fest, where attendees purchase a ticket and can sample a large variety of the brewery's flavored stouts. The brewery's past festivals have featured Pinstripe Stout, with flavors like candy bars and peanut butter. The brewery also has numerous weekly events, including trivia nights, live music and Taco Tuesdays (half-priced beer and tacos). There is never a dull evening at Blue Pants.

Although the brewery expanded, the Spratleys tried to maintain their unique blue pants–themed brand. The walls are a cheerful blue, and the

Patrons enjoying Blue Pants Brewery's beer garden. *Photo by Sarah Bélanger.*

beer flight paddles are shaped like little blue jeans. In the brewery's early days, each new beer was named after a pair of pants. After Knickerbocker Red came Amber Waders, Tuxedo Black, Black Chaps and Highwater Hoppy Tripel. Over the years, the beer names have become more traditional because, well frankly, they ran of styles of pants to name their beer after. The beer itself has only improved with time.

Although Jason was the original head brewer, six months after moving to the new location they hired Derek "Weedy" Weidenthal. Weedy is a classically trained brew master, and after he started working for Blue Pants, he continued his education at the Siebel Institute in Chicago and Germany. Weedy was able to take Jason's original beer recipes and perfect them. After several years, Weedy moved to Arizona, but his replacement, Neal Durbin, continues the tradition of creating "unreasonably good beer."

The brewery also has its distilling license and makes rum, gin, vodka and whiskey. It serves cocktails made with its liquor, which attracts the non-beer-drinking customers.

Being Madison's first brewery and one of the earliest breweries after the Free the Hops movement began, it was important to Jason and Allison to support fellow breweries. One way they have done this is to let new breweries contract-brew in Blue Pants facilities. Both Rocket Republic Brewing and Main Channel Brewing got their start this way. Despite supporting other breweries, Blue Pants also strives to be the best brewery in Alabama. "There is a fine line between supporting each other but still wanting to have the beer that is liked the most," said Allison. There is one thing that all the local breweries agree on: "The most important goal is developing people's love of craft beer."

Rocket Republic Brewing

Like many home brewers, Eric Crigger first dabbled in brewing after a family member—his wife, Tatum—bought him a Mr. Beer kit. It was 2003, and they had just moved to Alabama from Arizona, so he welcomed the new hobby. He brewed the beer and it was okay, but he wanted to try something more complicated. "I have an IT background, but I'm a tinkerer type personality," said Eric. "The Mr. Beer kit got me started, but it was limiting, so I started expanding my equipment and buying stuff to brew larger batches and with all grain, as opposed to the extracts that came with the kits."

He found the local store Pearly's Natural Foods and Mercantile, which sells home brewing supplies. There he was able to buy yeasts and some grains, and the rest he bought online. "Brewing with all grains gives you a lot more options," said Eric. "It opens up your color palette and lets you create much more diverse beers."

Eric started creating new, interesting styles and became quite immersed in his new hobby. He had been home brewing for years before he realized that his hobby was illegal in Alabama. "It wasn't illegal to buy home brew supplies; it was just illegal to make beer," said Eric. Once he found out it was illegal, he got involved with Free the Hops. Through the organization, he met fellow home brewers. "During that time period, I started hanging around the beer crowd," he said. "It was a small group of friends that I still have, many of which own breweries now."

As Eric's passion for craft beer grew, he wanted to understand how commercial breweries worked. At that time, "Olde Towne Brewing Company was the only brewery in the state, and thankfully it happened to be here in Huntsville," said Eric. It was 2009, and the brewery had reopened after a fire had destroyed its first location. Eric convinced owners Don Alan Hankins and Milton Lamb to let him come work at the brewery for free so he could learn the business. As luck would have it, Eric had accrued vacation time at work, so every Friday, he used a vacation day to volunteer at the brewery. "I started learning every aspect of the business," said Eric. "Milton took me to meet the distributor. I poured beer for the first time for Olde Towne at the first Rocket City Brewfest."

While volunteering at Olde Towne, Eric started creating a business plan for his own brewery. At the same time, some of his craft beer buddies, including Dan Perry, were doing the same. When Dan was starting Straight to Ale in 2009, he asked Eric to join him, but Eric declined, hoping to make it on his own.

As the next few months passed, the breweries Straight to Ale, Yellowhammer and Blue Pants started growing, but Eric could not quite find the right formula to get his brewery off the ground.

After two years of struggling, Eric decided to take a break. He set the business plan aside and continued to home brew, but just as a hobby. "When you try too hard to make something happen, it doesn't happen, and when you don't try anymore, it does happen. That has never been more true than in the history of this brewery," said Eric.

Interestingly, it would be a different hobby, ice hockey, that would help the brewery come to fruition. Eric played in an ice hockey league, and after

Kegs at Rocket Republic Brewing in Madison. *Photo by Sarah Bélanger.*

the games and practices, he would hang out with his teammates and drink a few beers in the parking lot. Being a home brewer, Eric would bring his latest recipe to test out on his teammates. One evening, he brought his pomegranate beer, and the other players loved it. His teammate John Troy asked if he had ever considered opening a brewery. Eric admitted he had a business plan, but he had never been able to get enough traction to get the brewery started. John told him to bring the business plan to the next practice, but not wanting to get too excited about the brewery again, Eric waited several weeks before he brought it to John. Once John saw it, though, he loved it, and a partnership was formed. Within a month, Rocket Republic Brewing Company had a business license. The brewery owners were Eric and his wife, Tatum Crigger, and John and his wife, Lynn Troy.

Although Eric had finally started his brewery, he still had a long road ahead of him. The owners found a brewery location in an industrial park in Madison, but it would take many months of hard work to get the brewery off the ground. In the meantime, Eric contract-brewed his beers at Blue Pants Brewing. Rocket Republic Brewing finally opened its doors in March 2014 to a thirsty and excited public.

The brewery released a spectrum of beers to appeal to numerous patrons. The malt lovers were fans of the Astronut Brown Ale, the craft

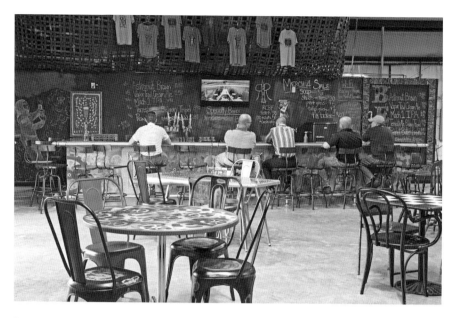

Rocket Republic Brewing's space and steampunk-themed taproom. *Photo by Sarah Bélanger.*

beer newbies could enjoy Vapor Trail Cream Ale and hop aficionados went wild for the Mach IPA. They also make sure they have a food truck at the brewery every day.

The taproom lives up to its namesake and is festooned with rockets. There is lots of usable floor space in the brewery, so the owners put it to good use. "We want the brewery's taproom to be a community asset." Tatum is a yoga instructor and teaches yoga classes in the brewery on Sundays. In addition to hosting numerous events, it is important to the owners that they use their brewery to benefit the community and make it available to charities. In 2016, they raised more than $6,000 for the American Cancer Society. They also hold events and sell T-shirts for Autism Awareness Month and Alzheimer's Awareness Month. "We try to support a charity every month, and though it's not always possible, we try," said Eric.

OLD BLACK BEAR BREWING

In 2008, like many Americans, Todd Seaton saw his 401(k) plan plummet. As he watched his hard-earned investments disappear, he wondered what

the point of all of it had been. In 2009, he lost his government contract job as a software engineer, and in 2010, his wife, Dawn Seaton, lost her government contract job as well.

These were clarifying moments that left Todd with the desire to invest in something more tangible for his future. When he started working again, he took the portion of his paycheck that typically went into his 401(k) and set it aside for investment into a brewery. The craft beer industry was just starting to pick up steam, and although he knew it would be a lot of work, Todd wanted something that he could build from the ground up. He had been home brewing for years, and the laws were changing enough to make commercial brewing viable. Plus "it seemed cooler to open a brewery" than invest in a 401(k), said Todd.

After a few years of saving, Todd, Dawn and a business partner started Old Black Bear Brewing Company. They named the brewery after Alabama's state mammal, the black bear, which used to inhabit much of the state before it was killed off by overhunting. Todd picked the black bear as the brewery's mascot because it reflected his love of nature and the great outdoors.

In 2012, Old Black Bear started out by contract brewing at Gadsden's Back Forty Beer Company. Some of the most successful breweries in the country started out by contract brewing, including the Boston Beer Company, which is responsible for Sam Adams beer. It is especially useful to breweries that are just starting. Back Forty also started out by contract brewing. "Contract brewing lets you test out a product on the market beforehand, so you can take that information to the bank and say, 'Here, I have a proof of concept,'" said Todd.

When Todd started brewing, he knew he wanted something different from the other local brewers, who were producing big, hoppy beers. He wanted to

Rustic signage at Old Black Bear Brewing Company. *Photo by Sarah Bélanger.*

create light session ales that were easy to drink and enjoy. According to Old Black Bear's website, its goal was to "create a great beer that real people can not only enjoy, but also relate to." The first beer he brewed was Milepost 652, a smooth-drinking beer with a slightly sweet taste. While Todd was contract brewing, Old Black Bear canned two of its most successful beers: Cave City Lager and Speckled Trout American Wheat.

For two years, Old Black Bear continued to grow and the owners

worked toward moving the brewery into a brick-and-mortar building. In early 2014, they found a location in downtown Madison that was perfect. The building had previously housed the Mexican restaurant Bandito Burrito, so it had a fully functional kitchen, a dining room and adequate parking. The empty building next door used to be Western Auto and was the perfect size for an attached brewhouse.

After numerous delays, Old Black Bear opened its doors in November 2014. The brewery continued to reflect Todd's love of the outdoors with a rustic interior, lots of bear décor and nature-related beer names such as Roaming Bear American Porter and Rockledge IPA.

He also created a group of beers called the Conservation Series, for which a portion of the proceeds goes to various environmental causes. The first beer in the series was an American amber ale called Whooping Crane Red Ale, which supports the National Whooping Crane Foundation. The whooping crane is one of the most endangered birds in North America, and the foundation is working to protect the bird from extinction. Each year, the brewery participates in a fundraising event to raise money and awareness for the cranes. The second beer in the series, Land Trust Trail Ale, raises money for the Land Trust of North Alabama.

The man behind Old Black Bear's signature easy-drinking beer is master brewer Stephen Tate. Tate is a classically trained brewer; he studied the craft

Old Black Bear Brewing Company's rustic- and natural-themed taproom. *Photo by Sarah Bélanger.*

in Chicago and Germany and became an International Master Brewer, one of only a handful in the entire Southeast. Tate had previously brewed for Straight to Ale Brewing, so he was very familiar with the local market and customers. Old Black Bear can now produce seven thousand barrels of beer a year, and Todd is already considering adding an off-site production facility to produce even more.

Although Todd had not initially planned on having a restaurant in the brewery, it ended up becoming an important part of Old Black Bear. The cuisine is crafted by Executive Chef Marcy Mays and her sous chef, Shawncey Smith, to complement the American-styled lagers and handcrafted cocktails.

Because restaurants typically have notoriously high employee turnover rates, Todd and Dawn worried that they would have to deal with a constant stream of new employees, which could be detrimental to the quality of service in the brewery. The Seatons felt that the best way to retain employees was to set the brewery up as a democracy and give the employees say in how Old Black Bear functioned. "If you create an environment where everybody loves to be here and everyone loves everybody they're working with, they never want to leave," said Todd. This has worked extremely well for the brewery, and the employees all think of one another like a family.

It was also important to the Seatons to support their fellow brewers. Todd said that there is a great deal of comradery between the local breweries. "Everyone works together. We just borrowed grain from Straight to Ale," and Old Black Bear helps out the other breweries as well. Because the craft beer market is so new, it is far from being oversaturated. "We're all trying to get a piece of the pie, but there's such a huge pie to have."

GADSDEN BREWERY

BACK FORTY BEER COMPANY

The year 2008 was not the easiest time to start a brewery in Alabama. Free the Hops had started to generate interest in the craft beer industry, but the laws were still extremely restrictive. Even the more discerning Alabama beer drinker was more likely to pick up a big-brand American lager than a full-flavored porter or IPA. But this did not stop Jason Wilson from jumping in and building his own brewery.

It all started when Jason took a trip to Crested Butte, Colorado, to visit his ski bum brother, Brad Wilson. While in Colorado, a state well known for its craft beer industry, Jason visited Crested Butte Brewery, which transformed his love of beer into a passion. "As Jason sipped the freshest beer he'd ever tasted at the Crested Butte Brewery, he caught the attention of the brew master behind the tanks," said Brad Wilson, who is now Back Forty Beer Company's director of sales and marketing. "That led to the first of what ended up being hundreds of brewery tours."

At the time Jason visited his brother, he was working a corporate job, but after his inspiring trip, he couldn't shake the idea of quitting his job and creating his own brewery. Jason knew that it would be hard to start a brewery in Alabama. Before 2008, the craft beer industry was sparse in the state, with very few breweries existing and none of them lasting. Additionally, much of the population didn't even know what they were missing out on

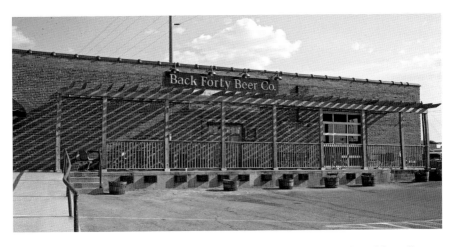

The exterior of Back Forty Beer Company. After contract brewing with Lazy Magnolia Brewing Company, it moved into its own building in 2011. *Photo by Sarah Bélanger.*

and were uneducated on the diversity of styles and intricate flavors of beer. The restrictive laws meant that the state was a virtual wasteland when it came to beer selection. "It was illegal to enjoy and downright impossible to manufacture really good beer here," said Brad.

But Wilson persisted. Knowing that he was in for a hard journey, he named his brewery Back Forty Beer Company after the agricultural term, which refers to the forty acres of land farthest from the barn. This acreage is typically the most difficult to cultivate and harvest, but as any good farmer knows, putting hard work into it can yield superior crops, since the back forty acres are underutilized and therefore rich in nutrients and potential. This is how Jason viewed building his brewery in the Deep South—a hard journey, but one that would yield a bountiful harvest.

Jason knew that the key to a fruitful craft beer harvest was a good set of recipes, so while he was still working his corporate job, he reached out to renowned brew master Jamie Ray for help. Jamie was working for the Montgomery Brewing Company but was able to brew full time with Back Forty after Montgomery Brewing closed. At that time, Jamie was a bit of an anomaly, being a master brewer in Alabama, a state not known for brewers, let alone highly decorated ones. When Back Forty was ready to start brewing, Jason knew that Jamie was the perfect person to create their beer. Jamie helped build Back Forty's stellar reputation by brewing modern interpretations of classic beer styles. The first beer was released in June 2009. It was Naked Pig Pale Ale, a crisp American pale ale that was mild enough

for the mainstream beer palate yet complex enough for the discerning craft beer enthusiast. It was the perfect beer to introduce an untapped population to the world of craft brewing.

To kick-start his dream, Jason needed money, so he reached out to his community. Friends and family came up with $35,000, which was just enough to get the first batches of beer into the market.

Back Forty started by contract brewing, renting space in an existing brewery, Lazy Magnolia Brewery, to make its beer. Contract brewing is a common practice for brewers just starting out; it allows a brewery to get its product into the market without having to spend massive amounts of money on expensive facilities and equipment. Lazy Magnolia owners Mark and Leslie Henderson were extremely supportive of Back Forty and helped the team learn the ins and outs of building a successful brewery. "They essentially left the key under the mat for us at Lazy Mag and let us learn about life on a full production-size brewery," said Brad.

When Back Forty was creating its first beer recipes, Alabama still restricted the alcohol content to 6 percent and the bottle size to sixteen ounces; furthermore, microbreweries were banned from selling their beer on premises. All of these laws gave the competitive advantage to breweries in other states. Because of this, Back Forty worked diligently with Free the Hops to reform Alabama's beer laws, and as the laws were modernized, breweries across the state found it

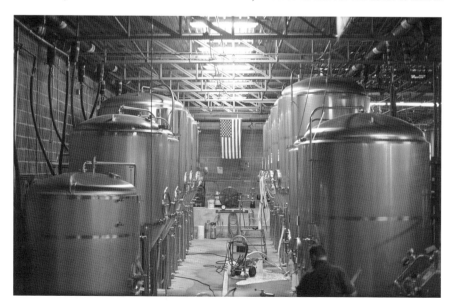

The tanks in Back Forty Beer Company. *Photo by Sarah Bélanger.*

easier to grow. When Back Forty's second beer, Truck Stop Honey Brown Ale, was released in 2010, it was an instant success and even won a Silver Medal at the Great American Beer Festival. The medal garnered the attention of many, and distribution offers started to pour in. According to Back Forty's website, "This was the spark needed to secure a small business loan and begin sourcing equipment for Back Forty's own facility."

Jason always knew that he wanted his own brick-and-mortar brewing facility, and at the very end of 2011, New Year's Eve in fact, Back Forty started brewing in its own building. The twenty-seven-thousand-square-foot 1940s brick building was located in Jason's hometown of Gadsden and had once housed the Sears Repair Center for the Southeast. Over the years, the brewery would continue to expand, adding a taproom, a bottling line, an entertainment area, a marketing center and even a test kitchen. Although Back Forty had no interest in entering the restaurant business, people would leave the brewery early to grab a bite. Back Forty had already been working with local farmers, so the brewery team worked out a trade program with local food producers to supply the restaurant of the brewery. "This year, we hired a classically trained chef, Jennifer Dewecse, to amp things up," said Brad. "Jenn can work wonders with the same produce, local meats and cheese that we continue to trade."

As the brewery continued to grow, it was important to Jason and the other employees to support their fellow brewers. Because Back Forty was one of the first modern breweries in Alabama, it took its role as a pioneer very seriously. "From day one, Back Forty's message has been 'a rising tide floats all boats,' and from the beginning, we've had a message of inclusion for all the breweries in Alabama," said Brad. "From consultation on every part of their business plans to helping secure capital and collective bargaining with suppliers, we've extended a hand to help our fellow brewers."

They also support their hometown of Gadsden, knowing that the community continues to support them. The brewery itself has become a center for both avid beer drinkers and those new to it. It is a great place for a diverse group of people to spend an evening. On a regular basis, the brewery hosts trivia nights, yoga classes and even Yappy Hour, a midweek gathering of beer-loving dog owners and their canine companions. Back Forty also gives to numerous charities, including United Way, the Birmingham Children's Hospital, the Humane Society and Ronald McDonald House, to name a few. "We literally haven't said no to a charity request going on eight years," said Brad.

As Back Forty continues to grow, it is important to the brewery team that it remains a valued part of the community.

GUNTERSVILLE BREWERY

MAIN CHANNEL BREWING

You cannot describe the city of Guntersville without mentioning its stunning lake. Lake Guntersville gives the town its relaxing vacation vibe and breathtaking landscape. The sixty-nine-thousand-acre body of water surrounds the city, providing residents and visitors with a scenic backdrop for fishing, camping, hiking and boating. The lake is a huge part of the city's identity, so when the Smith family decided to open a brewery, they knew that Lake Guntersville was going to be an important part of the brewery's brand.

Guntersville residents Brett Smith; his wife, Sarah; and his brother, Clay, wanted the lake to be at the heart of their brewery, and everything from the name, Main Channel Brewing, to the lake-themed décor is a reflection of their love for their community. "We want to be true to who we are, and we are Guntersville people," said Brett. "Guntersville is a proud little area."

Clay was the first one to get into brewing. As a chemical engineering student at Auburn University, the technical and chemical nature of home brewing was right up his alley. While living in Opelika, Alabama, Clay got an internship at the Auburn Ale House to learn the commercial side of the brewing industry.

As his brewing pastime grew, he introduced his brother to it, and the hobby flourished into a passion. The brothers started brewing inside Brett's house, but soon it expanded out into the garage and then spread across the

driveway. As the brothers bought more and more equipment, Alabama's beer laws were changing, and local breweries started opening up across the state. An hour east of Guntersville, Back Forty Beer Company had been brewing since 2009, and an hour west, Straight to Ale, Yellowhammer, Blue Pants, Old Black Bear and Salty Nut were doing the same, so commercial brewing in North Alabama was certainly possible. The Smiths started entertaining the idea of turning their hobby into a business.

Initially, starting a brewery was just idle talk between family members. They wondered if it was even possible to have a brewery in Guntersville, which had never in its history had a legal one. "We had bootleggers and all that kind of stuff, but we never had anyone legal in the city or even legal in the county," said Brett. That complicated things, because unlike Madison County, which had some pre-Prohibition laws already in place, neither Marshall County nor the City of Guntersville had precedent with which to guide them on how to legally set up a brewery.

Despite this, Sarah, Brett and Clay created articles of incorporation for the brewery, and the idle talk became a very real possibility. Now all they had to do was convince Guntersville's politicians and public to update brewery laws so they could start Main Channel. The city held several public hearings to determine the public's desire to have a brewery and the

Main Channel Brewing, which is Guntersville's first brewery ever. *Photo by Sarah Bélanger.*

city council's willingness to change the laws to allow for one. "We had to create a brewers' license for here in Guntersville," said Brett. "We didn't even have that."

The Smiths wanted to make sure that the city council understood what they were trying to accomplish, so they personally met with the mayor and city council members at their homes and businesses. Brett explained that they wanted to create a quality business that would cater to a high-caliber clientele, a place that the Guntersville community would be proud of—not just another honky-tonk with nickel beer nights and Jägerbombs. The city council saw their vision and approved the brewery unanimously.

As they started building the brewery in 2014, the Smiths made an effort to make Lake Guntersville part of the brewery's brand. The name Main Channel is part of the region's lexicon. "If you spend any time on the lake, you'll hear the phrase 'Main Channel,'" said Brett. He added that it is often used as a reference point, such as, "We're going to the bat cave, toward the dam and up the main channel."

The décor of the brewery reflects the lake community as well. A mural of a bridge covers the front of the building, and local art of the city adorns the inside walls. A giant fishing lure hangs in the taproom, and one of the paddles for beer flights is in the shape of a fish.

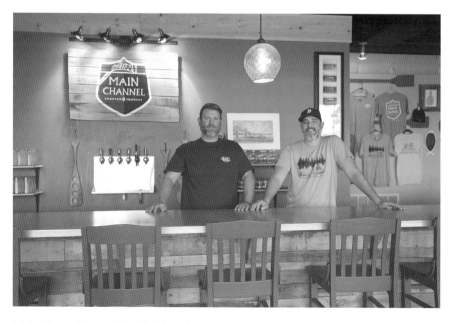

Main Channel owner Brett Smith and brewer Tyke Jordan in the brewery's lake-themed taproom. *Photo by Sarah Bélanger.*

Main Channel's beer was introduced to the public on October 17, 2015, at Downtown Albertville's first annual Craft Brewfest and was an instant hit with visitors and locals alike.

Although one of the first beers released was a bitter, yet smooth, double IPA called Faceplant, Main Channel also brews lots of lighter summer beers. It is another way for the brewery to reflect the Guntersville community, by brewing beer that is perfect for drinking while on the lake. "This is a market where you're on the lake or sitting at a boathouse all the time, so we want our beers to be enjoyed on Lake Guntersville—of course within the legal limits." This means brewing crisp, refreshing beers such as pale ales with a lower ABV. Their most popular beer is their Amber Ale, an American red ale designed for summers on the lake. Main Channel's website describes the Amber Ale as "perfectly paired with friends and family gathered for a Lake Guntersville Fish Fry." Head brewer Clay keeps in mind that Guntersville is still a transitional craft beer market, so he brews traditional-style beer. Once the public becomes more familiar with the styles, he adds his own twists to the recipe. The market is already changing, and customers are enjoying Main Channel's unique and stronger-flavored beers.

In addition to creating beer, Main Channel works to be a good neighbor and a pillar in its community. The owners try to give to numerous charities, and although Brett said there might be a day they will have to say no to someone, they have not had to turn down a charity event so far.

Although Brett, Sarah and Clay are looking to expand Main Channel in the future, for now they enjoy brewing quality beer and supporting their lake community.

CULLMAN BREWERY

GOAT ISLAND BREWING

Cullman natives John Dean, Mike Mullaney and Brad Glenn first met in elementary school. They remained friends through high school and into adulthood. John and Mike were even roommates at Auburn University. Mike was an avid home brewer, and when Alabama beer laws started to change, the trio talked about opening a brewery. But it wasn't until a community tragedy that they got serious about building their dream brewery.

On April 27, 2011, an F-4 tornado ripped through the tightknit community of Cullman, causing damage to more than eight hundred homes and nearly one hundred businesses. The destruction was devastating, but as tragedies often do, it brought the community closer.

After the tornado, John, an insurance agent, was busy assessing damages and processing claims for his clients. Much of it was tragic, but he did have a serendipitous encounter with client Gery Teichmiller. While examining the tornado damage, John noticed Gery's home brewing equipment. "You need to meet my friend Mike," John said, knowing that the two home brewers would hit it off.

A year later, at the 2012 Oktoberfest, John introduced Mike to Gery, and the two immediately struck up a friendship and started brewing together. Mike was skilled at IPAs and pale ales and adventurous with his brewing. Gery had decades of experience; he'd been brewing since the '70s and had

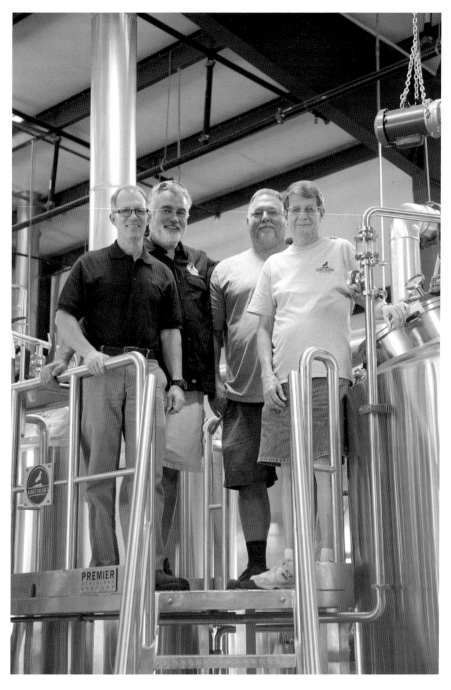

Goat Island Brewing owners Mike Mullaney, John Dean, Brad Glenn and Gery Teichmiller. *Photo by Sarah Bélanger.*

perfected several excellent lager recipes, as well as other classic brews. "As a result of the synergy of [our] relationship, both of [us] became much better brewers," said Mike. "[We] began to create and refine the recipes that became the beginning of the lineup that is available today."

The four friends met weekly in Gery's home brewing basement, which they had dubbed "Teck's Taproom," and made plans for starting a commercial brewery. An opportunity would present itself in 2013 when good friends of the brewers Wendell and Debbie Wood made plans to open a restaurant and wanted to serve local beer at it. The Blue Moose Café partnered with the four brewers to form Cullman's first brewpub since before Prohibition started in 1915. All four men would hone commercial brewing skills once they took on the role of the Blue Moose Brew Crew. Mike helped the Woods select a very small, one-barrel system that was capable of brewing thirty-one gallons of beer at a time. The brewery was small and a tight squeeze in the restaurant, but the brewers were excited to get their beers out to the thirsty Cullman residents.

The four brewers were not sure if their historically dry community would support the brewpub. It was so dry that for almost thirty years, Cullman hosted the world's largest dry Oktoberfest—the brewers had every reason to be concerned. "We braced ourselves for a backlash from people who are against alcohol in general, but that just never came," said Mike. "We all grew up in Cullman as a dry city and know people on both sides of that issue. Growing up here, you learn to respect people with differing opinions and go on living together in harmony. We bring that respect to the brewery, and from the feedback we are getting, everyone is pleased with the way we run the brewery and the values we bring to it." By supporting the community, the community, in turn, supported them. "We are amazed at the outpouring of appreciation and support we have gotten from the public," said Mike. In addition to their support, the beer was pretty popular as well.

The first beer they released was thirty-one gallons of Colonel Cullman's Festbier, a malty German marzen with hints of sweet crystal malts. The Brew Crew planned to debut a portion of the batch at the 2013 Cullman Oktoberfest and save the rest for the grand opening of the brewery side of the Blue Moose. They had ten gallons to last for the entire weeklong festival, but it sold out within thirty minutes. Gery spent the rest of the festival explaining to disappointed beer drinkers that they were out. "The Colonel's Festbier is still one of our best-selling beers," said Mike.

The opening of the Blue Moose was celebrated for having the first beer sold in Cullman since the 1880s. Because the beer was in limited supply, the

restaurant handed out numbers to people desperate for at least a taste. The Blue Moose had a full house, and once again, the beer was gone quickly. The guys knew they were on to something.

Although the beer grew in popularity, the Blue Moose sadly closed a short time later. But the Cullman residents had gotten their first taste of local craft beer and wanted more. The four brewers knew that they couldn't let their fans down, so Goat Island Brewing was born.

The brewers wanted to pay homage to the community that has supported them, so they named their brewery after Cullman landmark Goat Island, a local island on Smith Lake inhabited by, yep, goats. Brad, Mike and John visited it often growing up.

As the men built their brewery, they worked on new beer recipes, but they needed a good flagship brew to kick things off with. That is when the 2011 tornado would unveil another surprise with the discovery of an old journal written in a foreign language.

In 2014, one of John's insurance clients was going through some antiques that had been salvaged from his father's attic after the tornado struck. He found a small ledger, and inside was what looked like a beer recipe dated from May 19, 1837. Even more interesting was the signature: W. Richter, as in William F. Richter, owner of the Cullman saloon during the late 1800s. The client contacted John, who excitedly rushed to see the ancient beer recipe. John saw that it was a recipe written in a mix of German and English. It had the very promising phrase "make 32 gallons good beer." John and the others could not wait to try to brew it. "Knowing that W.F. Richter had a hotel and saloon in Cullman years ago, and we were starting a brewery....It was like God just kind of gave us a gift," said John. Another interesting connection to the recipe was Mike's wife, Lisa, who was the great-great-granddaughter of Richter. It seemed like destiny, but was the beer any good?

Step one was to translate the recipe. Mike worked for the German-based company Rehau, so he showed the recipe to a German co-worker. Unfortunately, it was written in an old version of German that he couldn't read, so the co-worker contacted his father in Germany to help out. The co-worker's father was eventually able to decipher the recipe, which turned out to be for a pilsner. Gery took the translated recipe and started brewing. It took six weeks to brew, and the wait was agonizing. They wondered if the beer would be good, as the recipe stated, or a waste of time and expensive ingredients. On April 1, 2014, the four brewers, along with their friends and family, met at Gery's house to taste the beer, which they had named Richter's Pils. To their delight, it was really good! "What are the odds?"

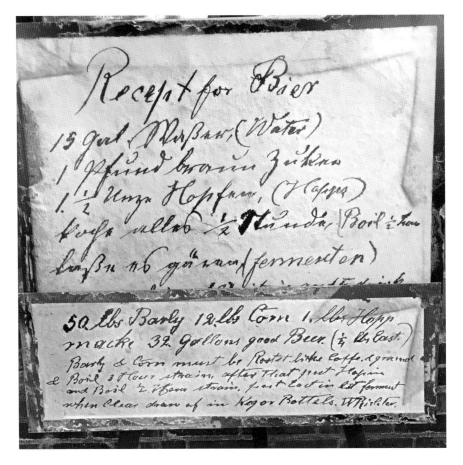

A page from a journal from the 1800s that contained a beer recipe by brewer Wilhelm Friedrich Richter. *John Dean.*

said Mike. "First to find this family recipe from Cullman, and then the beer tastes delicious." Richter's Pils would become one of the brewery's flagship beers and one of the first beers brewed by Goat Island Brewing. The fan favorite was a bronze medal winner of the 2016 Alabama Craft Beer Championship and was named the official beer of the 2016 Cullman Oktoberfest.

In April 2016, the friends finally opened Goat Island Brewing. As always, their community was there to support them. At the grand opening, Mike addressed the crowd: "We had a dream to create a local brewery in Cullman and put our city on the map for craft beer. Today, we celebrate the birth of that dream."

FLORENCE BREWERIES

SINGIN' RIVER BREWING

The Yuchi Native Americans, who lived in North Alabama, revered the Tennessee River. They called it the "singing river" because they believed a woman lived in it, and she would sing sweet songs to all who would listen. The sound the river makes as the water rushes across the reefs and the rocks does, in fact, sound like music, which can sometimes be loud and boisterous and sometimes soft and quiet. The Yuchi also said that if a person leaves the Tennessee River, it would call to you until you returned home. Florence residents Michelle and Rob Jones wanted to pay homage to their region and river roots, so they named their brewery Singin' River Brewing.

Michelle and Rob were both from communities near the Tennessee River—Michelle from Florence, Alabama, and Rob from Lawrenceburg, Tennessee. Rob had started home brewing as a student at the University of Tennessee–Knoxville. He had met Michelle on a blind date at a wine tasting, but it was not long before the two were enjoying craft beers together. Rob continued to brew beer at home, and the couple traveled around the country visiting numerous microbreweries.

After they were married, the Joneses traded in the Tennessee River for the Rocky Mountains by moving to Denver, Colorado, for their jobs. It was there that they encountered a rich craft beer culture unlike any they had experienced in the South. This was also where the idea of creating their own

brewery started to grow. "I think I always knew I wanted a brewery, but back in the '90s, there weren't small craft breweries everywhere," said Rob. "My eyes didn't open up to what was really going on with craft beer in the U.S. until I moved to Denver."

Rob and Michelle enjoyed Colorado and loved the craft beer culture there, but as the Yuchi's lore foretold, the singing river beckoned and they moved back to Florence in 2011. Since they had been gone, Alabama's beer laws had changed tremendously. Breweries could have taprooms, and the ABV had been raised to 13.9 percent. Alabama was experiencing a burgeoning craft beer industry, with one of the highest percentages of craft beer growth in the country. As of 2011, both Birmingham and Huntsville had several quality breweries, with more in development.

Florence is an artsy university town, with colorful historic houses, a dynamic culinary culture and unique festivals, but when the Joneses moved back, it lacked a craft brewery. Rob and Michelle hoped to remedy that.

Florence had never had a brewery, so there was no precedent on which to base their endeavor. Laws had to be created before they could start, but happily, the city was very supportive of their venture. Michelle and Rob assured the city that they would create a brewery that would become an integral part of the community. "We told [city officials] we were going to build a brewery that the city would be proud of," said Michelle.

As an avid home brewer and craft beer aficionado, Rob knew that a brewery is only as good as its beer, so he set out to find a professional brewer for Singin' River. As luck would have it, master brewer George Grandinetti was looking to move to Florence. George had extensive experience in the brewing industry and had worked with some of the top breweries in the country, including Bells Brewing and Rogue. George also had ties to the South. "I am not originally from Florence, but my mother's family has roots in this area going back before the Civil War," said George. "When I was a child, our family would spend a week or two every summer in Wayne County, Tennessee."

After months of planning and building, Singin' River Brewing opened in August 2014. Because Florence was new to the craft beer market, Singin' River started brewing well-crafted yet conventional beers. Handy's Gold came out first and is an easy-drinking blonde ale with subtle malts and mild hops. It became an instant hit and especially appealed to drinkers new to craft beer. But as the population became more beer-savvy, George was able to experiment and offer many different styles. Singin' River started brewing bigger and more flavorful beers, such as Tiger Chainsaw

Singin' River Brewing in Florence. It was the first brewery in Florence since before Prohibition. *Photo by Sarah Bélanger.*

Singin' River Brewing's owners, Rob and Michelle Jones, in their taproom. *Photo by Sarah Bélanger.*

Arms, a hybrid between a Belgian abbey tripel and American IPA with a potent 12.1 percent ABV. It won a gold medal at the 2016 Alabama Craft Beer State Championship. The brewery now carries its tried-and-true flagship beers, several popular seasonal brews and experimental one-off beers.

In 2015, Michelle enrolled at Auburn University's first offering of the Brewing Sciences and Operations program in order to stay knowledgeable about the business. She was one of the first women in Alabama to complete the program. It was an eighteen-hour distance-learning course that took a year to complete; it deepened her understanding of the brewing process and the business side of brewery ownership. Because Michelle already had a full-time job as an engineer, in addition to co-owning Singin' River, she had to get up at 4:30 a.m. so she could take her classes before arriving to work by 7:00 a.m. But her hard work paid off, and she said in an interview with the *Times Daily* that many of their inventory methods and operating procedures had been improved because of the course.

Although they had a well-designed brewery with quality beer, the Joneses took their brewery a step further by being a valuable part of the Florence community. They support numerous charities, host neighborhood festivals and partner with local restaurants to create a supportive and mutually beneficial relationship.

One unique community event that the brewery hosts weekly is a singalong called "Hops and Hymns." The event is a reflection of the region's love of music, which has always been an important part of the Muscle Shoals area. Many people do not realize that Muscle Shoals is home of the legendary Fame Studios, which has produced music for icons such as Aretha Franklin, Otis Redding and the Osmonds. Every Wednesday night, Singin' River hosts "Hops and Hymns," where patrons enjoy an evening of singing church hymns, beer and appetizers.

Although the Joneses initially worried that the people of Florence would not accept a craft brewery, their fears were unfounded, and they have had massive support from the community. In return, they strive to be good neighbors. "I don't know if I've ever been more proud of the city of Florence," said Michelle. "The community is working together to be better every day."

BLUEWATER BREWING

Much of Arron Hannah's childhood was spent swimming and fishing in Bluewater Creek, which branches off from the Tennessee River and winds through the city of Elgin, twenty miles from Florence. He spent hours on the water with his father in their vintage motorboat, and the creek has always been near and dear to his heart. Arron grew up in the Muscle Shoals area, but when he got older, he wanted to spread his wings and see more of the world. So, in 2003, he moved to Birmingham to pursue a culinary degree from Culinard. A year after, Arron moved even farther away and transferred into the culinary program at Johnson and Wales University in Denver, Colorado.

While attending Johnson and Wales, Arron and his roommate bought the roommate's father a beer brewing kit. After a few months, the roommate's father still had not used the kit, so they stole it back and brewed the beer themselves. From that moment on, Arron was in love with brewing, and what started out as a diversion quickly turned into a passion. He attended the Great American Beer Festival in Denver, which really started his enthusiasm for the commercial side of the craft beer industry. He got an unpaid internship with Rock Bottom Brewery in Colorado Springs, where he began to learn the business of brewing from the inside. Arron then got the opportunity to work for Short's Brewing and moved to Traverse City, Michigan, to further his brewing education.

Although Arron was planning on staying in Michigan, a trip back home to Alabama in 2009 would change things. While he was visiting the Tennessee Valley, he found that a lot had evolved with Alabama's craft beer industry since he had been gone.

"That was 2009, right when the Brewery Modernization Act had hit, so Straight to Ale was blowing up, Blue Pants and Yellowhammer were blowing up," said Arron. The craft beer industry was just starting to make an impact in Alabama, and Arron wanted to be part of it. So, he moved to Huntsville and started educating himself about brewing in Alabama. "I got to interact with all of those guys [the local brewers] by joining the Rocket City Brewers club," said Arron. He started helping out the owner of Blue Pants Brewing, Mike Spratley, in addition to working full time at a Huntsville restaurant.

In 2012, he moved back to Florence so he could open a brewery in his hometown. He named the brewery Bluewater after the creek where he spent so much of his childhood. Arron paired up with a business partner, Patricia Wilkins, a certified accountant, and they started making plans for opening

Above: Bluewater Brewing Company's signage. Bluewater is Florence's second brewery. *Photo by Sarah Bélanger.*

Right: Bluewater Brewing Company's owner, Arron Hannah. Arron hopes to brew a fully locally produced beer. *Photo by Sarah Bélanger.*

their brewery. They incorporated on July 4, 2013, but it was not going to be easy or quick. The partners would spend three years dealing with red tape and complications before the brewery would be fully functional. They struggled to keep the costs of starting the brewery down and had to do a lot of the work themselves, which meant the brewing was slow to get off the ground. "We really tried to do this on a shoestring budget," said Arron. "I wanted to show people that you could still have a quality product and not have to break the bank doing it."

Soon after the brewery opened in 2016, Patricia moved to Huntsville. This ended up being beneficial for the brewery because she was able to work as a liaison for the Madison County craft beer market. She also uses her accounting expertise to maintain the financial side of things.

Once they had the building and equipment, Arron used his brewing experience and culinary background to create beer recipes. One of the first beers he brewed was a Belgian quad, playfully named River Monster, a nickname he calls his infant son. Although Arron brews quality, traditional beers, such as Flat Bottom Belgian Blonde, he also likes to experiment with culinary flavors to create unique beers. "Sometimes the brewery is

like a mad scientist laboratory," he said. Some of his more adventurous beers include a plum and smoked cardamom dubbel, as well as a chocolate raspberry cayenne porter.

Most of Bluewater's beers are seasonal or specialty beers. Arron strives to brew with ingredients that are in season; he brews with root vegetables such as beets in the winter and with muscadines in the fall. It is important to him that he brews with as many local ingredients as possible. This forces him to think outside the box for many of his recipes. "Everyone knows pumpkin beer is popular in the fall, but we live in Alabama, and I can get five hundred pounds of sweet potatoes from a farm five minutes up the road," said Arron. He also used local and seasonal ingredients to brew his Lemon Basil Blonde Ale and Orange Sage Black Pepper Session Ale. He has partnered with Old South Malting Company, which locally produces malt, and he is trying to grow his own hop crops with a friend. As the brewery grows, he hopes that he will be able to use more and more local ingredients. "Having a fully farm-to-table beer would be huge for us," said Arron.

The partners intentionally kept the brewery small so it could grow organically and locally. It was very important to them that it reflected North Alabama and the Florence community, and it was easier to do that if the brewery was small. One way they are serving the communities is by creating a hospitable environment for local up-and-coming artists. Bluewater is a big supporter of those just starting out. "We're kind of the underdog in town [because we're so new], and we've come to embrace that," said Arron. "We want to give other underdogs a place to express themselves." The brewery's beer garden has a stage for new musical groups. Bluewater also hosted a Graffiti Jam and invited local artists to permanently display their artwork on the side of the building.

The brewery aims to be inclusive and family friendly. Arron welcomes people to visit the brewery with their kids and dogs, and the beer garden has games such as Frisbee golf. Arron even brews gourmet sodas and plans on getting some taps for customers who want a non-alcoholic drink. He is even considering getting a pigmy goat to reside at the brewery.

Although they have just started, Arron and Patricia are hoping to expand their brewery soon. The city is revitalizing the area of Florence surrounding the brewery, and Bluewater is getting in on the ground floor. They are looking forward to seeing how the neighborhood changes over the next few years and are happy that Bluewater gets to be a part of it.

NORTH ALABAMA'S EXPANDING BEER MARKET

As of 2017, the Alabama local beer industry is unrecognizable from ten years earlier. The state's brewers had been hiding in garages and basements, covertly brewing beer for decades. So when the laws finally changed, they emerged with experience and passion for their craft, which the thirsty public was ready to drink up.

Much of the continued success of North Alabama's beer industry can be credited to Free the Hops. Although the movement started in Birmingham, much of Free the Hops' current activity has moved to the Huntsville chapter. The organization has also shifted its focus away from legislative change to become strong advocates of beer education. "Huntsville being such a highly educated town, it was a natural progression for Free the Hops to teach people what they are drinking and why they like it," said Free the Hops president Carie Partain. "Everyone likes to feel smart about something they enjoy." Free the Hops does this through bottle-sharing clubs and information-based tastings and by supporting individuals in the industry who want to continue their beer education.

Another impact that the diversified selection of beer had was to change the demographic of Alabama's typical beer drinkers. With more choices, people who thought they did not like beer discovered that though they may not like mild American lagers, they loved malty stouts or citrusy wits.

Free the Hops also hosts the annual Rocket City Brewfest, which allows participants to taste more than 350 beers, most of which are from Alabama. The two-day beer festival draws over 6,500 beer lovers and raises money for Free the Hops and Alabama Brewers Guild.

Crowds of attendees at the 2016 Rocket City Brewfest in Huntsville. *Photo by Sarah Bélanger.*

Decatur recently started its first chapter of Free the Hops. As more breweries pop up across the region, there will likely be new chapters in the future.

When Alabama's brewing and beer laws changed, it was expected that the number of breweries would increase, and that did indeed happen. What was not expected was how many additional businesses would benefit from the changing laws, as well as the positive social impact that the new beer industry would have on the state. In addition to generating tax revenue, many of the breweries also sponsor numerous charities and support their communities by offering the brewery as an event venue.

A THRIVING INDUSTRY

The development of Alabama's craft beer market has generated other related businesses. The food truck industry grew and expanded alongside the craft beer industry. Local musical groups and artists also got their start by performing in breweries; in fact, many of the beer venues have stages to accommodate entertainers.

In areas like Huntsville, where there are numerous breweries, beer tours are a popular pastime. "Bikes and Brews" is a group of bicyclers that get together at least once a month to visit various beer venues. "Beer Hop" is a trolley tour that transports patrons to three different breweries to enjoy sampling flights at each location.

Artists are also benefiting from the breweries. Bluewater Brewing, Main Channel Brewing and Mad Malts all display the work of local artists in their breweries. Some of the artists create work for the beer itself, such as Southern Growler, a company that designs stunning ceramic containers to transport beer.

SOUTHERN GROWLER

Growlers are containers made specifically for draft beer. They got their name from the "growling" sound the beer makes sloshing inside the jug. Growlers are especially useful to transport beer from taps; several North Alabama breweries, such as Green Bus Brewing and Mad Malts, do not currently package their beer, so growlers are the only way to get their brews to go. Southern Growler had been selling its handcrafted ceramic vessels for several years, but when the Growler Bill went into effect in June 2016, there was an increased demand for the containers, and the business really took off. Two master ceramists, Aaron Keen and Clay Krieg, design and create the artisan growlers, which they sell throughout the country. The business is located on the back end of the Huntsville store Liquor Express, a beer shop with more than one hundred beers on tap, which makes it a perfect location to sell these handcrafted growlers.

BOTTLE SHOPS

As the laws changed, craft beer bars and bottle shops opened up across North Alabama. They are places where customers dare not ask for the watered-down, big-brand American lagers. These shops and taverns have highly educated employees, some of whom have literally traveled the country or the world to learn about beer.

Damon Eubanks opened his bottle shop after honing his beer knowledge by working in all tiers of Alabama's three-tier system. He worked on the manufacturing tier with Straight to Ale, the distributing tier with Alabev/

Brown glass growlers at Wish You Were Beer in Madison. *Photo by Sarah Bélanger.*

Birmingham Beverage Company and the retailing tier with The Nook. He discovered that he preferred the retail side of the industry, so in August 2014, he and his wife, Laura, opened the craft beer shop Wish You Were Beer. The Eubanks wanted their bottle shop to be something new in Madison County, and according to their website, they aimed "to make your beer shopping experience educational and noteworthy, not simply an errand." With the success of their first location, Damon was able to open a second location at Huntsville's Campus 805 in February 2017. The new location sells home brewing supplies in addition to the extensive beer selection.

When Damon first started volunteering with Free the Hops, he never expected a bottle shop like Wish You Were Beer would thrive in North Alabama, let alone several of them. "This far exceeded anything I'd ever thought [the beer industry] would have become," said Damon. "When Straight to Ale was coming on board and we had Olde Towne Brewing already, I thought, 'Wow, Huntsville's going to be a town with two breweries. That's unreal.' And to think today we have nine."

In addition to a vast supply of different styles of beer, bottle shops have highly trained and knowledgeable employees. Damon and two of his employees, Jessica Holmes and Jeremy Conception, are certified cicerones, which officially designates them to be beer experts. To achieve cicerone

certification, an individual has to pass a series of difficult tests designed by authorities in the beer industry. The tests are extremely rigorous, and the fail rate of cicerone certification is higher than the fail rate for the California bar exam.

Another certified cicerone in North Alabama is Rich Partain, general manager of the craft beer shop Das Stahl Bierhaus. Rich was very active with Free the Hops early on and even started a Cullman chapter while the city was still dry. North Alabama residents also enjoy the craft brew shops Old Town Beer Exchange, Liquor Express and Stem and Stein, to name a few.

North Alabama also has craft beer bars and taprooms such as The Nook in Huntsville. The Nook existed before the beer laws started changing and is credited with giving many breweries their debut into the market. It provided a venue to serve beer before it was legal for breweries to have taprooms. Yellowhammer, Straight to Ale and Blue Pants all released their beers for the first time at The Nook.

LEAVENDARY

Beer making is a complex and technical process, which makes it especially appealing to the many scientists and engineers of North Alabama. The craft beer market has inspired bioengineers to create better beer.

Entrepreneur Peyton McNully was hanging out with his friend Todd Seaton, owner of Old Black Bear Brewing. Shortly after Todd opened his brewery, Peyton learned that the Huntsville bioengineering institute for technology Hudson Alpha was offering office space in its complex to companies that specialized in life sciences. While drinking beers with his buddy Todd, Peyton mentioned the opportunity and said he was trying to think of a life sciences company he could start. Todd said, "Yeast is a life science. It is alive; it's a biological organism. Why don't you cultivate our yeast for us?" Peyton loved the idea, and a week later, the yeast propagating company Leavendary was born. It was the first company of its kind in the entire southeastern United States. Since quality yeast is essential to brewing consistent batches of beer, breweries were thrilled with the new company. Several local breweries use Leavendary yeast, including Old Black Bear, Back Forty Beer Company and Below the Radar Brewpub.

In addition to locally cultivated yeast, local farmers are also exploring ways of growing grains and even hops for beer. Some of the local brewers and farmers have started experimenting with different variants of plants to see which ones grow best in Alabama. In the future, it is likely that some breweries will produce a beer with all local ingredients.

Women in the Industry

For decades, many people, including women, had the view that beer is a drink for only men. It was, after all, groups of women who were the first to fight against the evils of the saloons. But as Alabama became more educated about the craft beer industry, those beliefs started to evolve. In addition to seeing more women enjoying a pint, Alabama started seeing more women working in the industry. In 2017, the industry has far more women brewery owners, brewers and sales representatives than when locally produced beer first came to the state. Current Free the Hops president Carie Partain is the first female president to preside over the entire organization, and more will likely follow in her footsteps.

Wish You Were Beer general manager Jessica Holmes said that when she first started in the industry, people often dismissed her as not being knowledgeable about beer, but that has changed over time. Now she uses her expertise as a certified cicerone to teach monthly beer classes at Wish You Were Beer.

Blue Pants Brewing owner Allison Spratley founded a group called Crafty Ladies that allows women to come together to enjoy craft beer and learn more about it.

As more women become part of Alabama's craft beer community, all sectors of the industry are benefiting from the diversity.

New Breweries

In the early days of Alabama's craft beer revival, the industry grew the fastest in Huntsville and Birmingham, likely due to these being cities of transplants and travelers who had already experienced the joys of locally produced craft beer in other states. But as the industry grew more, born and

bred Alabamians discovered locally crafted beer, and interest spread across the state. As of the beginning of 2017, North Alabama already has several new breweries in the process of opening, and the region can expect more of them in previously unexplored markets. Decatur will likely have its first brewery, Cross-Eyed Owl Brewing, within a year.

Cross-Eyed Owl Brewing

Henry "Trey" Atwood got into home brewing after a group of friends he plays poker with wanted to do something other than play cards. Trey's brother-in-law suggested they try home brewing, so the group of friends pitched in and bought a kit; once Trey tried it, he was hooked. He loved that it allowed him to be creative, which was not always possible at his job as a cyber-security defense contractor. Before he knew it, he was buying more intricate equipment and developing his own recipes. For six years, it remained a hobby. Then, in April 2015, Trey found out he had colon cancer. He had to have part of his colon removed and went through chemotherapy. "I was sitting there in my first chemo session, and I told my wife that I wanted to open my own brewery," said Trey. "I wanted to do something for me. You don't know how long you have in this world, so I wanted to do something that I liked." Trey's wife, Erin, was very supportive, so they started planning Cross-Eyed Owl Brewing.

Initially, the Atwoods wanted to open in Athens, but the city was not very receptive to opening a brewery, so they looked to Decatur. Trey contacted Decatur's Community Development Department and was thrilled to learn that the city would welcome a new brewery with open arms.

After some searching, Trey finally found the perfect location: a three-thousand-square-foot vintage building in downtown Decatur. As of the start of 2017, he was still in the building stages of the brewery but plans to open in August of the same year.

THE NEXT TEN YEARS

It is hard to anticipate what the craft beer market will look like in ten years. Some people fear that cities will become oversaturated with breweries, but statistics show that Alabama's consumption of local craft beer is only 1.5

percent of the total consumption of all beer in the state, so there is definitely room for growth.

Despite being slow to change its laws, once Alabama did, the industry grew rapidly and is catching up to the more established craft beer industries across the United States. "In Alabama, we kind of assume that we're behind everyone else, but as far as our beer laws, the way they are now we're actually ahead of a lot of other states and I don't think people realize that," said Jessica Holmes.

Whatever the beer landscape will become, North Alabama will put its own twist on it. By creating craft beer that features local flavors and ingredients, as well as engineering new and ingenious ways to create and promote their beer, Alabama's breweries will create a style all their own.

BIBLIOGRAPHY

Advertisements

Badlun. "$25 Reward." Advertisement. (Huntsville) *Alabama Republican*, September 19, 1819.

Geo. Winter Brewing Co. Bock Beer. Brewery 55th St. betw. 2d & 3d Avs., N.Y. / Louis Kraemer N.Y. [circa 1900] Image. Retrieved from the Library of Congress.

Jas. Badlun Wm Badlun. "Huntsville Brewery." Advertisement. (Huntsville) *Alabama Republican*, September 19, 1819.

Wm Badlun. "$100 Reward." Advertisement. (Huntsville) *Alabama Republican*, September 25, 1819.

Blogs

AL.com. "Our View: The Legislature Should Raise Alabama's 16-Ounce Maximum Size for Beer Bottles." February 23, 2012. Accessed February 6, 2017. http://blog.al.com/birmingham-news-commentary/2012/02/our_view_the_legislature_shoul_1.html.

Alabama Brewers Guild. "ABG Opposes Proposed Rule Change." January 15, 2014. Accessed November 21, 2016. http://albeer.org/blog/archives/1320.

———. "ABG Supports the Gourmet Bottle Bill." April 4, 2012. Accessed November 21, 2016. http://albeer.org/blog/archives/811.

———. "About Those Proposed Regulations." August 4, 2016. Accessed November 21, 2016. http://albeer.org/blog/archives/8595.

————. "Alabama Alcoholic Beverage Study Commission Makes Recommendations." January 12, 2016. Accessed October 22, 2016. http://albeer.org/blog/archives/8156.

————. "Alabama Beer Production Up 47% in 2013." April 3, 2014. Accessed November 21, 2016. http://albeer.org/blog/archives/1577.

————. "Alabama Brewers Guild Supports Homebrew Legalization." October 11, 2012. Accessed February 5, 2017.

————. "Alabama Growler Bill Had a Vote on the Senate Floor Thursday… Almost." May 25, 2015. Accessed October 23, 2016. http://albeer.org/blog/archives/4970.

————. "Alabama Is Missing 3,000 Jobs." February 11, 2015. Accessed October 23, 2016. http://albeer.org/blog/archives/2346.

————. "Alabama's Congressional Delegation Supports the Craft Brewing Industry." December 19, 2015. Accessed October 22, 2016. http://albeer.org/blog/archives/8113.

————. "Auburn University Establishes Program in Brewing Science." February 17, 2013. Accessed November 21, 2016. http://albeer.org/blog/archives/1037.

————. "Badlun Brothers Imperial Porter: Our 2016 Guild Collaboration Beer." January 21, 2016. Accessed October 23, 2016. http://albeer.org/blog/archives/8128.

————. "Beer Consumption Stays Steady While Local Brewing Industry Grows." July 11, 2013. Accessed November 21, 2016. http://albeer.org/blog/archives/1214.

————. "Breweries Bring Urban Revitalization." February 2, 2015. Accessed October 23, 2016. http://albeer.org/blog/archives/2145.

————. "Brewers Association Announces 2009 Craft Brewer Sales Numbers." July 27, 2011. Accessed November 21, 2016. http://albeer.org/blog/archives/436.

————. "Brewers Association Releases State-by-State Economic Impact Study." January 16, 2014. Accessed November 21, 2016. http://albeer.org/blog/archives/1376.

————. "Brewery Jobs Bill Worth 655 Jobs, $12 Million in Taxes, $100 Million Total Economic Output." June 16, 2015. Accessed October 23, 2016. http://albeer.org/blog/archives/4987.

————. "Building Alabama." February 16, 2015. Accessed October 23, 2016. http://albeer.org/blog/archives/2521.

————. "Deep Ellum Brewery of Texas Sues Over Off-Premise Sales." October 1, 2015. Accessed October 23, 2016. http://albeer.org/blog/archives/5420.

———. "Failing to Compete." February 9, 2015. Accessed October 23, 2016.

———. "5 Facts about Brewery Direct and Retail Sales Laws." July 6, 2015. Accessed October 23, 2016. http://albeer.org/blog/archives/5230.

———. "4 Proposals for the Alabama Alcoholic Beverage Study Commission." July 1, 2015. Accessed October 23, 2016. http://albeer.org/blog/archives/5175.

———. "Free the Hops & the Gourmet Beer Bill and Other Legislative Issues." Accessed February 7, 2017.

———. "The Future of Beer." February 18, 2015. Accessed October 23, 2016. http://albeer.org/blog/archives/2560.

———. "Governor Bentley Signs HB176 into Law." March 26, 2016. Accessed November 21, 2016. http://albeer.org/blog/archives/8275.

———. "Growler Bill Passes Legislature." March 16, 2016. Accessed October 22, 2016. http://albeer.org/blog/archives/8260.

———. "HB530 Supports Tourism in Alabama." April 11, 2013. Accessed November 21, 2016. https://albeer.org/blog/archives/1113.

———. "HB96: A Craft Brewers License for Alabama." March 3, 2015. Accessed October 23, 2016. http://albeer.org/blog/archives/2784.

———. "HB355 Introduced." January 24, 2014. Accessed November 21, 2016. http://albeer.org/blog/archives/1508.

———. "HB289 Introduced." February 10, 2012. Accessed November 21, 2016. http://albeer.org/blog/archives/737.

———. "A History of Alabev." Accessed April 12, 2016.

———. "HJR 154: An Alabama Alcoholic Beverage Study Commission." April 30, 2015. Accessed October 23, 2016. http://albeer.org/blog/archives/4841.

———. "Homebrew Bill Passes House." April 11, 2013. Accessed November 21, 2016. http://albeer.org/blog/archives/1111.

———. "Homebrew Legal in Alabama." May 13, 2013. Accessed November 21, 2016. http://albeer.org/blog/archives/1142.

———. "How Colorado Helped Its Craft Brewing Industry Reach the Top." November 9, 2015. Accessed October 22, 2016. http://albeer.org/blog/archives/8083.

———. "How North Carolina Attracted Hundreds of Millions in Investment from Craft Beer." October 28, 2015. Accessed October 22, 2016. http://albeer.org/blog/archives/8033.

———. "Our Thoughts on HB581." March 6, 2014. Accessed November 21, 2016. http://albeer.org/blog/archives/1537.

————. "Our Written Comments on the Proposed Regulations." August 11, 2016. Accessed November 21, 2016. http://albeer.org/blog/archives/8615.

————. "A Rare Prohibition." February 5, 2015. Accessed October 23, 2016. http://albeer.org/blog/archives/2224.

————. "SB211 and HB176 Filed in the Alabama Legislature." February 11, 2016. Accessed October 22, 2016. http://albeer.org/blog/archives/8211.

————. "SB294 Passes Senate." February 22, 2012. Accessed November 21, 2016. http://albeer.org/blog/archives/753.

————. "SB294 Signed by Governor Bentley." May 16, 2012. Accessed November 21, 2016. http://albeer.org/blog/archives/836.

————. "A Second Beer Bill. SB128: Allow Enforceable Contracts for the Beer Industry." March 15, 2015. Accessed October 23, 2016. http://albeer.org/blog/archives/2812.

————. "6 Signs that Alabama Puts Its Small Business Breweries at a Competitive Disadvantage." July 15, 2015. Accessed October 23, 2016. http://albeer.org/blog/archives/5290.

————. "St. Stephens Stout: An Alabama Brewers Guild Collaboration." March 9, 2015. Accessed October 23, 2016. http://albeer.org/blog/archives/2851.

————. "38 States Allow Brewery Self-Distribution, but Not Alabama." July 8, 2015. Accessed October 23, 2016. http://albeer.org/blog/archives/5239.

————. "3 Reasons Why Beer Distributors Should Support Growlers from the Brewery." February 25, 2015. Accessed October 23, 2016. http://albeer.org/blog/archives/2662.

————. "2015 Legislative Recap for the Alabama Brewing Industry." June 14, 2015. Accessed October 23, 2016. http://albeer.org/blog/archives/5051.

————. "Uncompromising?" April 25, 2015. Accessed October 23, 2016. http://albeer.org/blog/archives/4709.

————. "What Are 'Congruent, Competitive, and Consistent' Beer Laws?" October 19, 2015. Accessed October 22, 2016. http://albeer.org/blog/archives/8013.

————. "What Does HB96 Actually Do?" March 8, 2015. Accessed October 23, 2016. http://albeer.org/blog/archives/2871.

————. "Why Craft Beer Brewers and Consumers Should Support Three-Tier." February 24, 2015. Accessed October 23, 2016. http://albeer.org/blog/archives/2613.

———. "Why the Alabama Alcoholic Beverage Study Commission Should Visit North Carolina." May 23, 2015. Accessed October 23, 2016. http://albeer.org/blog/archives/4959.

Albeer.org. "Brewers Association Reports 2010 Mid-Year Growth for U.S. Craft Brewers." August 20, 2010. Accessed November 21, 2016. http://albeer.org/blog/archives/445.

Beer Activist. "Birmingham Boycotts Bud." January 30, 2008. Accessed February 6, 2017. https://beeractivist.wordpress.com/2008/01/30/birmingham-boycotts-bud.

Carter, Stuart. "Steps Toward Freedom." FreeTheHops.org, March 11, 2008. Accessed November 21, 2016. http://www.freethehops.org/blog/2008/03/steps-towards-freedom.

Chandler, Kim. "Gov. Robert Bentley Signs Home Brew Bill (updated)." AL.com, May 9, 2013. Accessed November 21, 2016. http://blog.al.com/wire/2013/05/gov_robert_bentley_signs_home.html.

Crider, Beverly. "Bangor CaveUnderground Nightclub and Speakeasy." AL.com, January 2, 2014. Accessed April 12, 2016. http://blog.al.com/strange-alabama/2014/01/bangor_cave_--_underground_nig.html.

Dennycreek.blogspot.com. "Illegal Homebrew." April 16, 2008. Accessed November 21, 2016. http://dennycreek.blogspot.com/2008/04/illegal-homebrew.html.

Doyle, Steve. "Below the Radar Brewery Coming to Downtown Huntsville's Historic Times Building." AL.com, October 17, 2011. Accessed May 12, 2016. http://blog.al.com/breaking/2011/10/below_the_radar_brewery_coming.html.

Kline, Danner. "Alabama Goes from Craft Beer Wasteland to Model of Progress." *Danner. In Birmingham.*, March 15, 2016. Accessed November 21, 2016. https://dannerinbham.wordpress.com/2016/03/15/alabama-goes-from-craft-beer-wasteland-to-model-of-progress.

———. "Gourmet Beer Bill Wins the Shroud Award." FreeTheHops.org, June 8, 2007. Accessed November 21, 2016. http://www.freethehops.org/blog/2007/06/gourmet-beer-bill-wins-the-shroud-award.

Lyke, Rick. "Free the Hops Calls for Boycott of Anheuser-Busch in Birmingham." *Lyke2Drink*, February 1, 2008. http://lyke2drink.blogspot.com/2008/02/free-hops-calls-for-boycott-of-anheuser.html.

Murphy, Dan. "Brewery Modernization Act Changes the Rules for Alabama's Breweries and Brewpubs." AL.com, June 9, 2011. Accessed December 23, 2016. http://blog.al.com/whats-brewing/2011/06/brewery_modernization_act_chan.html.

Roberts, Dan. "Birmingham News on SB192." FreeTheHops.org, May 12, 2011. Accessed November 21, 2016. http://www.freethehops.org/blog/2011/05/birmingham-news-on-sb192.

——. "The Brewery Modernization Act." FreeTheHops.org, January 20, 2010. Accessed November 21, 2016. http://www.freethehops.org/blog/2010/01/the-brewery-modernization-act.

——. "Details of the Substitute." FreeTheHops.org, May 3, 2011. Accessed May 12, 2016. http://www.freethehops.org/blog/2011/05/details-of-the-substitute.

——. "An Open Letter to Alabama's Beer Wholesalers Regarding SB128." *Alabama Brewers Guild*, March 17, 2015. Accessed October 23, 2016. http://albeer.org/blog/archives/2842.

Tomberlin, Michael. "Alabama Beer Advocacy Group Asking Legislature to Allow Larger Containers." AL.com, February 25, 2012. Accessed November 21, 2016. http://blog.al.com/businessnews/2012/02/alabama_beer_advocacy_group_as.html.

——. "Alabama Beer Brewing Laws Near Change, but Some Say Not Far Enough." AL.com, May 12, 2011. Accessed November 21, 2016. http://blog.al.com/businessnews/2011/05/alabama_beer_brewing_laws_near.html.

——. "Alabama Bill Aims to Help Brewpubs through Deregulation." AL.com, January 24, 2010. Accessed October 24, 2016. http://blog.al.com/businessnews/2010/01/alabama_bill_aims_to_help_brew.html.

——. "Alabama Free the Hops Group Calls Off Beer Boycott." AL.com, May 3, 2011. Accessed November 21, 2016. http://blog.al.com/businessnews/2011/05/alabama_free_the_hops_group_ca.html.

——. "Alabama Gov. Bentley Signs Bigger Beer Container Bill into Law." Blog.al.com, May 16, 2012. Accessed May 12, 2016. http://blog.al.com/businessnews/2012/05/alabama_gov_bentley_signs_bigg.html.

——. "Brewers Are Hopping to the Alabama Suds Rush." AL.com, October 14, 2010. Accessed November 21, 2016. http://blog.al.com/businessnews/2010/10/brewers_are_hopping_to_the_ala.html.

——. "Free the Hops Calls for Boycott of Anheuser-Busch." AL.com, April 23, 2011. Accessed November 21, 2016. http://blog.al.com/businessnews/2011/04/free_the_hops_calls_for_boycot.html.

——. "Free the Hops Calls for Boycott of Beers Stocked by Anheuser-Busch Distributors in Alabama." AL.com, April 23, 2011. Accessed February 6, 2017. http://blog.al.com/businessnews/2011/04/free_the_hops_calls_for_boycot_1.html.

————. "Some Big Changes Appear Headed for Olde Towne Brewing." AL.com, February 17, 2011. Accessed May 12, 2016. http://blog.al.com/breaking/2011/02/some_big_changes_appear_headed.html.

White, Ronnie. "Olde Towne Brewing Company Destroyed by Fire." AL.com, July 5, 2007. Accessed May 12, 2016. http://blog.al.com/breaking/2007/07/old_towne_brewing_destroyed_by.html.

Wilkinson, Kaija. "Move Over Miller: Alabama Law Allowing More Alcohol in Beer Paves the Way for New, High-End Products." AL.com, October 11, 2009. Accessed October 24, 2016. http://blog.al.com/press-register-business/2009/10/post_3.html.

Books

Bamforth, Charles. *Beer Is Proof God Loves Us: Reaching for the Soul of Beer and Brewing.* Upper Saddle River, NJ: FT, 2011.

Blumenthal, Karen, and Jay Colvin. *Bootleg: Murder, Moonshine, and the Lawless Years of Prohibition.* New York: Roaring Brook, 2011.

Cagle, Kay, and Greg Richter. *Legendary Locals of Cullman County, Alabama.* Charleston, SC: Arcadia Publishing, 2014.

Carradine, John. *Taxed to Death in Alabama as a Result of Prohibition.* New York: United States Brewers' Association, 1909.

Chapman, Elizabeth Humes. *Changing Huntsville, 1880–1899.* Huntsville, AL: Historic Huntsville Foundation, 1989.

Ellis, Edward S. *The Life of Colonel David Crockett.* Philadelphia: Porter & Coates, 1884. Web, May 12, 2016.

Farr, Margaret, William H. Sharpton and William A. Glenn. *The Pictorial History of Cullman's First 100 Years.* Cullman, AL: Cullman County Museum, 1979.

Fisk, Sarah Huff. *Civilization Comes to the Big Spring, Huntsville, Alabama, 1823.* Huntsville, AL: Pinhook Pub., 1997.

Fleming, Walter L. *Civil War and Reconstruction in Alabama.* New York: Columbia University Press, 1905.

Flynt, Wayne. *Alabama in the Twentieth Century.* Tuscaloosa: University of Alabama Press, 2004.

Hackney, Sheldon. *Populism to Progressivism in Alabama.* Princeton, NJ: Princeton University Press, 1969.

Hamilton, Virginia Van Der Veer. *Alabama: A History.* New York: Norton, 1984.

Hennessey, Jonathan, Tom Orzechowski, Mike Smith and Aaron McConnell. *The Comic Book Story of Beer: The World's Favorite Beverage from 7000 BC to Today's Craft Brewing Revolution.* Berkeley, CA: Ten Speed, 2015.

Higginbotham, Evelyn Brooks. *Righteous Discontent: The Women's Movement in the Black Baptist Church, 1880–1920.* Cambridge, MA: Harvard University Press, 1993.

Hoole, William Stanley, Addie S. Hoole, Charles P. Smith, J.D. Anthony and William Van Jacoway. *Early History of Northeast Alabama and Incidentally of Northwest Georgia.* Tuscaloosa, AL: Confederate Pub., 1979.

Jackson, Harvey H. *Inside Alabama: A Personal History of My State.* Tuscaloosa: University of Alabama, 2003.

Jones, Margaret Jean. *Cullman County Across the Years.* Cullman, AL: Modernistic Printers, 1975.

Jones, Virgil Carrington. *True Tales of Old Madison County (Alabama): Tales of Early Madison County Pioneers and Their Historic Old Homes.* Huntsville, AL: Historic Huntsville Foundation, 1992.

Okrent, Daniel. *Last Call: The Rise and Fall of Prohibition.* New York: Scribner, 2010.

Pritchard, R.E. *The Year Book of the United States Brewers Association.* N.p.: United States Brewers Association, 1911.

Rankin, John Patrick. *Memories of Madison: A Connected Community, 1827–2007.* Virginia Beach, VA: Donning, 2007.

Sellers, James Benson. *The Prohibition Movement in Alabama, 1702 to 1943.* Chapel Hill: University of North Carolina Press, 1943.

Simpson, Fred B., Mary N. Daniel and Gay C. Campbell. *The Sins of Madison County.* Huntsville, AL: Triangle, 1999.

Stalcup, Brenda. *Women's Suffrage.* San Diego, CA: Greenhaven, 2000.

Stephens, Elise Hopkins. *Historic Huntsville: A City of New Beginnings.* Sun Valley, CA: American Historical, 2002.

Taylor, Thomas Jones. *A History of Madison County and Incidentally of North Alabama, 1732–1840.* Tuscaloosa, AL: Confederate Pub., 1976.

Whitley, Carla Jean. *Birmingham Beer: A Heady History of Brewing in the Magic City.* Charleston, SC: The History Press, 2015.

Williams, Randall, ed. *The Alabama Guide: Our People, Resources, and Government 2009.* Montgomery: Alabama Department of Archives and History, 2009.

Wilson, Charles Reagan. *Myth, Manners and Memory.* Vol. 4. Chapel Hill: University of North Carolina Press, 2006.

Interviews

Allison, John. E-mail interview by Sarah Bélanger, January 19, 2017.

Atwood, Trey. Personal interview by Sarah Bélanger, December 7, 2016.

Below, Steve. Telephone interview by Sarah Bélanger, February 2, 2017.

Bodecker, Dan. Personal interview by Sarah Bélanger, December 2, 2017.

Bramon, Chris. Personal interview by Sarah Bélanger, November 23, 2016.

Bruton, Leslie. Personal interview by Sarah Bélanger, December 6, 2016.

Cole, Brent. Personal interview by Sarah Bélanger, November 30, 2016.

Couch, Ethan. Personal interview by Sarah Bélanger, November 25, 2016.

Couch, Ethan. Personal interview by Sarah Bélanger, October 6, 2015.

Cousins, Martin. Telephone interview by Sarah Bélanger, February 2, 2017.

Crigger, Eric. Personal interview by Sarah Bélanger, November 25, 2016.

Dean, John. Personal interview by Sarah Bélanger, October 7, 2016.

Eubanks, Damon. Personal interview by Sarah Bélanger, December 8, 2016.

Grandinetti, George. Online interview by Sarah Bélanger, January 20, 2016.

Hannah, Arron. Personal interview by Sarah Bélanger, October 12, 2016.

Holmes, Jessica. Personal interview by Sarah Bélanger, December 14, 2016.

Hughes, Dr. Kaylene. Personal interview by Sarah Bélanger and Kamara Bowling Davis, May 18, 2016.

Jones, Rob. Personal interview by Sarah Bélanger, October 12, 2016.

Kline, Danner. E-mail interview by Sarah Bélanger, December 20, 2016.

Mullaney, Mike. E-mail interview by Sarah Bélanger, January 7, 2017.

Oberman, Scott. Personal interview by Sarah Bélanger, December 12, 2019.

Partain, Carie. Personal interview by Sarah Bélanger, November 14, 2016.

Perry, Dan. Personal interview by Sarah Bélanger, December 5, 2016.

Roberts, Dan. E-mail interview by Kamara Bowling Davis, January 31, 2017.

Seaton, Todd. Personal interview by Sarah Bélanger, November 28, 2016.

Sledd, Jason. Personal interview by Sarah Bélanger, November 28, 2016.

Smith, Brett. Personal interview by Sarah Bélanger, November 1, 2016.

Spratley, Allison. Personal interview by Sarah Bélanger, December 1, 2016.

Turner, Henry. Personal interview by Sarah Bélanger, September 19, 2016.

Wilson, Brad. E-mail interview by Sarah Bélanger, November 1, 2016.

Newspaper, Magazine and Journal Articles

AL.com and Press-Register Editorial Board. "Update Liquor Laws to Allow Bigger Bottles." Editorial, March 2, 2012. Web, November 21, 2016.

Berry, Lucy. "Alabama Ranks 50th in Per-Capita Economic Beer Impact; Policy Makers Must Remove Manufacturing Barriers to Support Growth." AL.com, February 11, 2015. Web, November 21, 2016.

———. "Blue Moose Café & Brew Pub to Release 1st Commercial Beer Produced in Cullman Since 1800s." AL.com, October 1, 2013. Web, May 12, 2016.

———. "Craft Beer Continues to Climb in Alabama as Brewers Push for Statewide Growler Sales." AL.com, June 16, 2015. Web, October 23, 2016.

———. "Gov. Bentley Signs Beer-to-Go Bill, Law Goes into Effect in June." AL.com, March 24, 2016. Web, November 21, 2016.

———. "Inspired by Home Brewing Kit, Culinary Grad Partners with CPA to Launch Florence Craft Brewery." AL.com, September 20, 2013. Web, May 12, 2016.

———. "Learn Why Cigar City Brewing Passed Over Alabama for Expansion and What One Group Hopes to Do About It." AL.com, November 28, 2014. Web, October 23, 2016.

———. "Madison County Brewers Thrilled with State Recommendations for Growler Sales." AL.com, January 12, 2016. Web, May 12, 2016.

Campbell, Kay. "Alabama Religious Leaders v. State Alcohol Laws. Who's Winning?" AL.com, July 7, 2015. Web, October 23, 2016.

Cason, Mike. "ABC Board to Modify Rule on Collecting Names of Beer Buyers." AL.com, September 12, 2016. Web, November 21, 2016.

———. "Rule Requiring Breweries to Take Names of Beer Buyers on ABC Agenda." AL.com, September 27, 2016. Web, November 21, 2016.

Causey, Donna R. "Actual Article Written by Mrs. Peter Bryce in 1880 about the Temperance Movement." *Alabama Pioneers*, August 4, 2015. Web, April 12, 2016.

Corey, Russ. "Microbrewery Owner First Alabama Woman to Complete Auburn Brewing Science Program." *Times Daily*, August 31, 2015. Web, May 12, 2016.

———. "There's Beer Brewing at Florence's Second Craft Brewery." *Times Daily*, January 25, 2016. Web, May 12, 2016.

Crownover, Danny K. "The Vagabond—History of the Drinking Water Fountain on First & Broad Streets in Gadsden." *The Messenger*, January 22, 2016. Web, February 5, 2017.

Cullman Sense. "John W. Sparks: Cullman County's 15th Sheriff Killed in the Line of Fire." December 10, 2015. Web, March 27, 2016.

Estes, Cary. "Craft Beer Rolls Over the State Line." *Business Alabama*, May 2015. Web, October 23, 2016.

————. "Tapping into a New Market." AL.com, May 2013. Web, November 21, 2016.

Finch, Michael, II. "Craft Brewers: Alabama Laws Stifle Growth of Burgeoning Beer Industry." AL.com, July 20, 2015. Web, October 22, 2016.

Florence Times. "Temperance Day." March 5, 1915.

————. "Temperance Notes." January 8, 1915.

————. "Temperance Notes." January 22, 1915.

Huntsville (AL) Redstone Rocket. "New Boat Patrols Tennessee River." August 22, 1962.

————. "Redstone Navy Is on Guard." July 7, 1953.

Huntsville (AL) Weekly Mercury. "Detective in Employ of Judge Lawler Concealed Whiskey in D.D. Overton's Barn Friday Night." May 26, 1916.

Huntsville Herald. "Mrs. Carrie Nation." October 31, 1902.

Huntsville Times. "Mr. Pleasant Left Note." June 10, 1916.

————. "Nalls Resigns." June 22, 1916.

————. "Sheriff Kills Self." June 23, 1916.

————. "W.T. Lawler Is Murdered." June 18, 1916.

Huntsville Weekly Mercury. "Body of Judge Lawler Found Near Whitesburg." June 21, 1916.

Gadsden Times. "Our View: Approve Gourmet Bottles." March 2, 2012. Web, November 21, 2016.

————. "Our View: Brewery Law Overdue for Update." July 29, 2010. Web, November 21, 2016.

Gray, Jeremy. "Alabama Alcohol Laws, Attitudes Rapidly Changing." AL.com, July 10, 2015. Web, October 23, 2016.

Groark, Virginia. "Making Beer at Home Is Now Legal Nationwide." *ABA Journal*, August 1, 2013. Web, May 12, 2016.

Hanson, David J., PhD. "Biography: Richmond Pearson Hobson." Alcohol Problems & Solutions, February 19, 2014. Web, April 12, 2016.

Jackson, Harvey H. "Jackson: Liquor Laws and Loopholes: A Brief History of How Alabama Regulates Alcohol." *Randolph Leader*, October 31, 2012. Web, April 12, 2016.

Kazek, Kelly. "On Repeal Day: 7 Places Alabamians Bought Illicit Liquor during Prohibition, including Speakeasy Caves, Underground Tunnels." AL.com, December 5, 2014. Web, May 12, 2016.

Moore, David. "The Tale of the Richter's Pils: What Are the Chances?" *2016 Cullman Oktoberfest*, October 2016, 51–54.

Moore, Trent. "Goat Island Readies Launch with 4 Signature Brews." *Cullman Times*, April 10, 2016. Web, May 12, 2016. www.cullmantimes. com/news/goat-island-readies-launch-with-signature-brews.

Murphy, Dan. "With Relaxed State Laws, Nothing Wrong with the 'Beer We Got.'" *Lagniappe Mobile*, March 23, 2016. Web, October 22, 2016.

Poe, Kelly. "Beer To-Go Bill Passes Alabama Legislature, Still Needs Governor's Signature." AL.com, March 16, 2016. Web, October 23, 2016.

———. "Goat Island Brewing Prepping to Open as Cullman's First Brewery." AL.com, September 16, 2015. Web, May 12, 2016.

Poor, Jeff. "Politics of Beer Offer a Lesson in Free Market Economics." *Lagniappe Mobile*, April 15, 2015. Web, October 23, 2016.

Rohr, Nancy. "I'll Drink to That: John Dunn's Tavern Ledger." Web, February 8, 2017.

Simon, Stephanie. "In Bible Belt, Brewing Is a Battle." *Los Angeles Times*, March 10, 2008. Web, May 12, 2016.

Snider, Bernice M. "Huntsville's First Night Club: The Dancing Cave." *Old Huntsville History and Stories of the Tennessee Valley*, 1991.

Stone, Andrea. "Frustration Over Liquor Laws Brewing." *USA Today*, January 24, 2008. Web, May 12, 2016.

Tabler, Dave. "Prohibition Comes to Alabama. Again." *Appalachian History*, June 30, 2015. Web, April 12, 2016.

Tomberlin, Michael. "Free the Hops Calls for Boycott of Anheuser-Busch." AL.com, April 22, 2011. Web, November 21, 2016.

———. "Free the Hops Calls for Boycott of Beers Stocked by Anheuser-Busch Distributors in Alabama." AL.com, April 23, 2011. Web, November 21, 2016.

Voices, Guest. "How New Legislation Could Impact Beer and Wine Sales." AL.com, March 15, 2016. Web, October 24, 2016.

White, Richard. "Death and Re-birth of Alabama Beer." *Business History* 58, no. 5 (2015): 785–95.

Whitley, Carla Jean. "Alabama's Beer History Long Predates Its Current Spate of Breweries." AL.com, October 12, 2015. Web, April 12, 2016.

Websites

Abcboard.state.al.us. Web, January 16, 2016.

Adamsbeverages.net. "Company History." Web, April 12, 2016.

Alabama Department of Archives and History. "Alabama Governors Charles Henderson." February 7, 2014. Web, April 12, 2016.

Alcap.com. Web, February 14, 2016.

American Spirits. "The Rise and Fall of Prohibition." Web, April 12, 2016.

Andrews, Evan. "10 Things You Should Know About Prohibition." History. com, January 16, 2015. Web, May 12, 2016.

Bhamwiki.com. "Free the Hops." March 24, 2016. Web, October 22, 2016.

Cohen, Jennie. "Drink Some Whiskey, Call in the Morning: Doctors & Prohibition." History.com, January 17, 2012. Web, April 12, 2016.

Cosman, C.P., R. Anderson and J. Hardin. "ADAH: Alabama Moments (Alabama Religion in the 20th Century)." Alabamamoments.alabama.gov. Web, April 12, 2016.

Digital History. "Prohibition." Web, April 12, 2016.

Dirty South News. "Alabama: If You Have 5 Gallons of Beer in Your Car, You Can Go to Jail." December 31, 2011. Web, November 21, 2016.

McGough, Will. "Hidden Craft Beer Gem: Huntsville, Alabama." CraftBeer. com, July 9, 2016. Web, October 22, 2016.

McGunnigle, Nora. "How Two Friends Started Alabama's Craft Beer Boom." The Alcohol Professor, June 26, 2015. thealcoholprofessor.com. Web, April 12, 2016.

McHops, Barley. "BIGGER BOTTLES IN BAMA." ALEHEADS, April 30, 2012. Web, January 24, 2017.

Murray, Jennifer M. "Richmond Pearson Hobson." Encyclopedia of Alabama, April 21, 2015. Web, April 12, 2016.

Natta, Andre. "Free the Hops Boycotting Birmingham Budweiser." *The Terminal,* January 23, 2008. Web, October 22, 2016.

Pierce, Dan. "Flock Family." Encyclopedia of Alabama, May 23, 2013. Web, April 12, 2016.

Reeves, Jay. "Alabama Legalizing To-Go Beer from Breweries." Enewscourier. com, May 28, 2016. Web, November 21, 2016.

Spiess, DJ. "Alabama Alcohol Beverage Control Pays Homebrewer a Visit." Fermentarium.com, June 14, 2016. Web, May 12, 2016.

Tribune News Services. "Proposed Alabama Beer Rule Prompts Privacy Concerns." Chicagotribune.com, August 5, 2016. Web, December 23, 2016.

Wallace, Harry E. "History of the Shoals, Page 7." Rootsweb.ancestry.com. Web, May 12, 2016.

Other Sources

Conner, Kristen. "Proposed ABC Regulations Worry Craft Beer Advocates." WHNT.com, August 3, 2016. Web, November 21, 2016.

———. "Recommended Changes to Alabama's Beverage Law Would Allow Growlers, Direct Sales." WHNT.com, January 12, 2016. Web, October 22, 2016.

The Daily Show. "Spirited Away." Comedy Central, New York, October 18, 2005.

Powell, Jeanie. "Some Wish to Raise Alcohol Content in Beers Brought and Made in Alabama." WAFF.com. Web, November 21, 2016.

Rosenburg, R.B. "Emmet O'Neal (1911–15)." *Encyclopedia of Alabama*, June 30, 2008. Web, May 12, 2016.

U.S. Army War College/U.S. Military History Institute. *Senior Officers Oral History Program*. By Dr. John L. McDaniel. Carlisle Barracks, Pennsylvania, 1985.

Wasson, S.E. "What It Proposes." Digital image. Alabama Textual Materials Collection. Web, February 8, 2017.

INDEX

ABOUT THE AUTHORS

SARAH BÉLANGER is a writer, food photographer and beer blogger based in North Alabama. Her work has appeared in dozens of publications, including *NoAla Magazine*, *Huntsville's Event Magazine*, *Southern Living*, *Cooking Light* and *Betty Crocker*. She is a regular contributor to the Huntsville Madison County Visitor's Bureau's blog, www.ihearthsv.com. Sarah first experienced craft beer as a master of journalism student at the University of Alabama. While researching the book, she learned that she has a gluten allergy and, alas, can no longer drink beer, but she remains a beer enthusiast in support of all those dedicated to making and sharing the best beer possible. Sarah lives with her husband in Madison, Alabama. This is her first book.

KAMARA "KAMI" BOWLING DAVIS earned a Bachelor of Science degree in secondary education from the University of North Alabama, with specialties in history and political science. She worked for a decade at the U.S. Space and Rocket Center, rising from Space Camp counselor to director of sales. Kami is a veteran of the U.S. Army and a self-proclaimed "Cat Lady" who gained her interest in craft beer through exposure to the vast quantities consumed by her husband. Rather than fight against his love of beer, and knowing that resistance was futile, Kami jumped right in. She became an expert in the field, knowing more about beer than her husband. She resides in North Alabama with her loving husband, three cats, two dogs and an evil rabbit.

Visit us at
www.historypress.net

···

This title is also available as an e-book